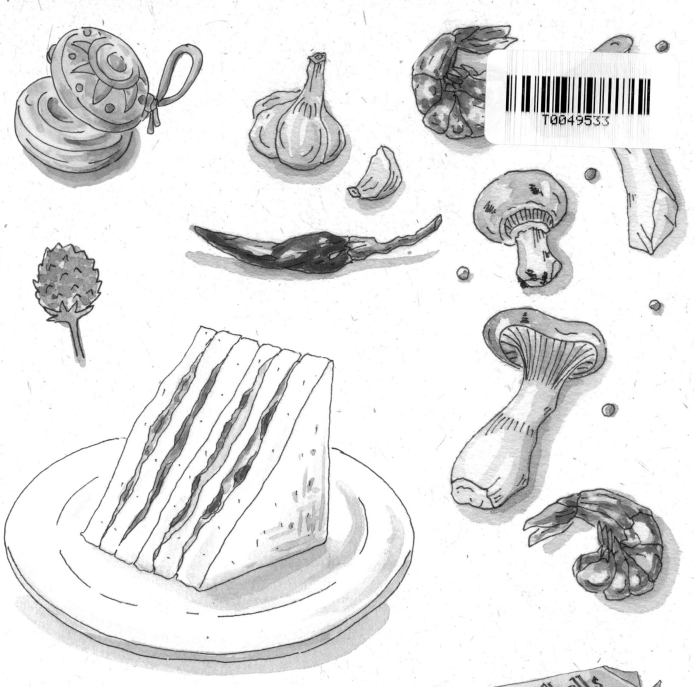

FOOLPROOF
SKETCHING & PAINTING
TECHNIQUES FOR BEGINNERS

TOMOKO KURAMAE

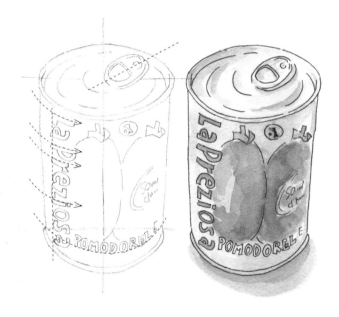

TUTTLE Publishing

Tokyo | Rutland, Vermont | Singapore

CONTENTS

Why I Wrote This Book

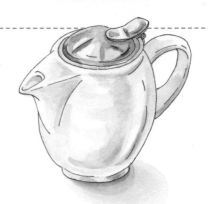

"I'm no good at drawing! Every time I try it looks wrong somehow..."

Have you had thoughts like these? No need to worry! Consider the points below:

- Where is the center?
- Where are lines parallel, and where are they perpendicular?
- What about the sense of depth?

A shape where a cylinder that swells in the middle has a handle and a pouring spout on opposite sides

If you identify this information and master the basic box and cylinder shapes, you can synthesize and extrapolate to draw all kinds of objects!

As long as the reference points are accurate—even if your lines wobble a bit, or the shape is a little warped, or your paint strays outside the lines—don't worry! Instead of getting too caught up in the details, just apply color quickly to create pictures that are all your own.

In this book, I explain the points that you need to know about and put that information together with fun sketching exercises where you'll draw objects around you composed of their basic shapes.

If you find something you want to draw, don't hold back—just draw it! A world of creative fun will open up to you!

—Tomoko Kuramae

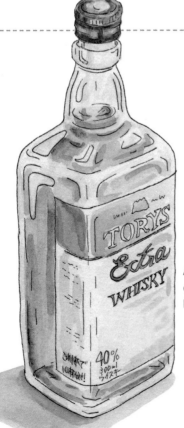

A shape that is a combination of a box and a cylinder

A shape where two cylinders of different sizes are stacked

Examples of the Shapes You'll Be Able To Draw with This Book:

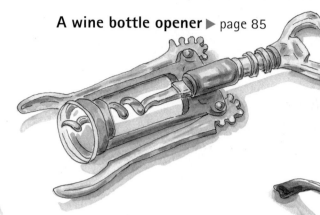

A wine bottle opener ▶ page 85

A tea canister ▶ page 10

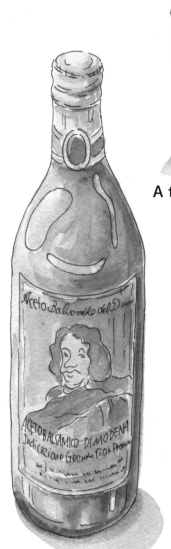

Your Table is Filled with Objects!

Although these may look like complicated shapes at first glance, if you adopt a logical mindset and observe them carefully, you can easily draw them without making mistakes!

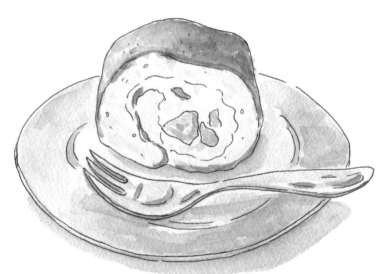

A bottle of balsamic vinegar ▶ page 40

A slice of roll cake on a plate ▶ page 76

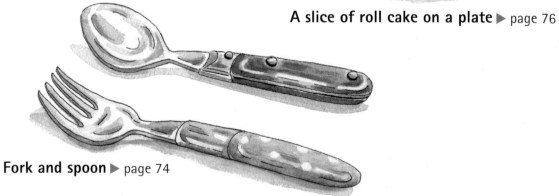

Fork and spoon ▶ page 74

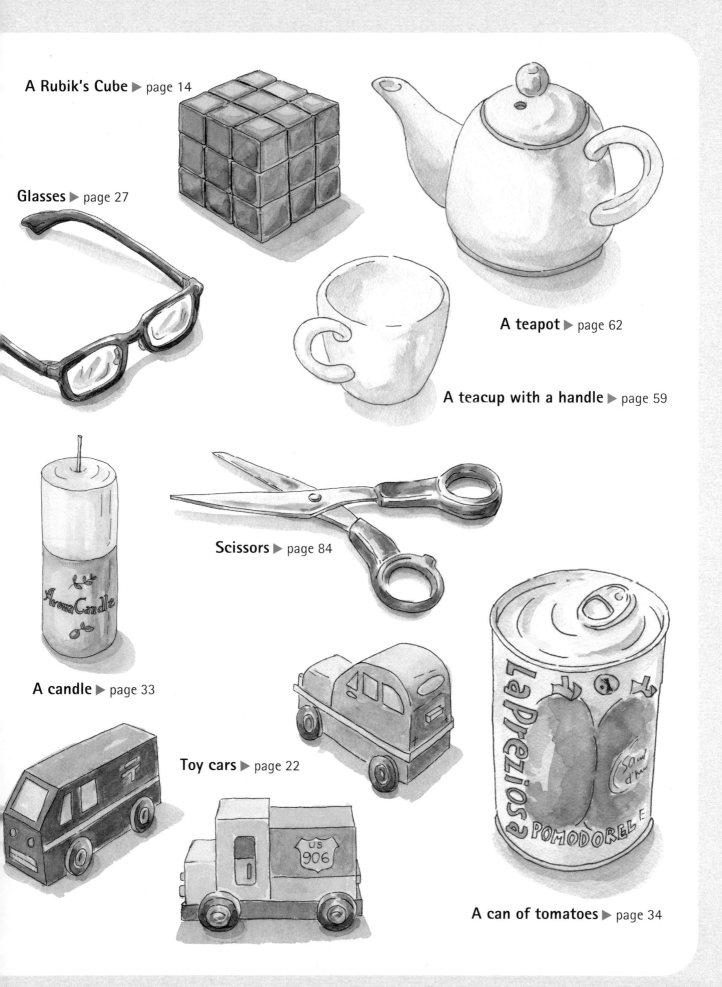

Drawing Objects with a Box Shape

If you can draw a box, you can draw any object (excluding organic shapes) realistically!

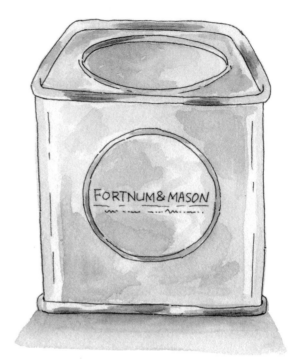

FORTNUM & MASON

A tea canister Instructions ▶ page 10

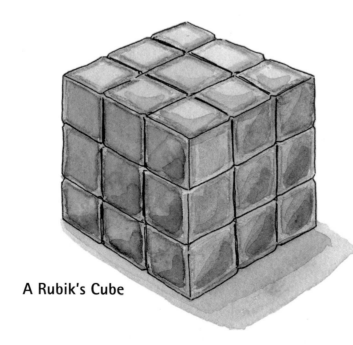

Instructions ▶ page 14

A Rubik's Cube

A box can look very different depending on the viewer's vantage point. Observe the boxes and cubes in your environment carefully!

How Surfaces Look in Relation to Your Eye Level

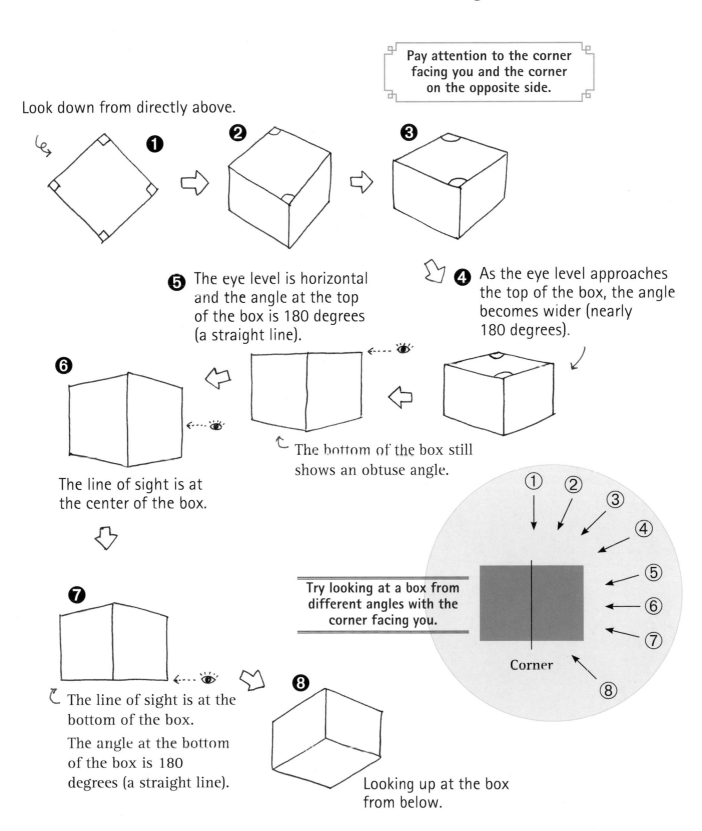

Pay attention to the corner facing you and the corner on the opposite side.

Look down from directly above.

❶

❷

❸

❺ The eye level is horizontal and the angle at the top of the box is 180 degrees (a straight line).

❹ As the eye level approaches the top of the box, the angle becomes wider (nearly 180 degrees).

❻

The bottom of the box still shows an obtuse angle.

The line of sight is at the center of the box.

Try looking at a box from different angles with the corner facing you.

Corner

① ② ③ ④ ⑤ ⑥ ⑦ ⑧

❼

The line of sight is at the bottom of the box.

The angle at the bottom of the box is 180 degrees (a straight line).

❽

Looking up at the box from below.

A Quick Look at Perspective Rules

Even people who think this looks difficult at first may, after actually drawing and coming back to this page, find that it is easy to understand after all.

Single Point Perspective

The key to using *single point perspective* is that one side of the box must be facing the viewer.

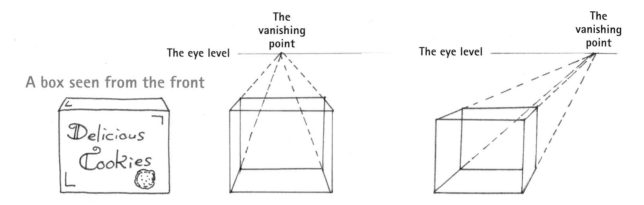

A box seen from the front

When the lines that indicate depth are extended, they converge at a point called "the vanishing point." The vanishing point is always at the eye level of the viewer (this is also called "the horizon line"). Drawing objects with one vanishing point is called "single point perspective."

Two-Point Perspective

When two vertical faces of the box are visible, *two-point perspective* is used. The right side and the left side go toward two different vanishing points.

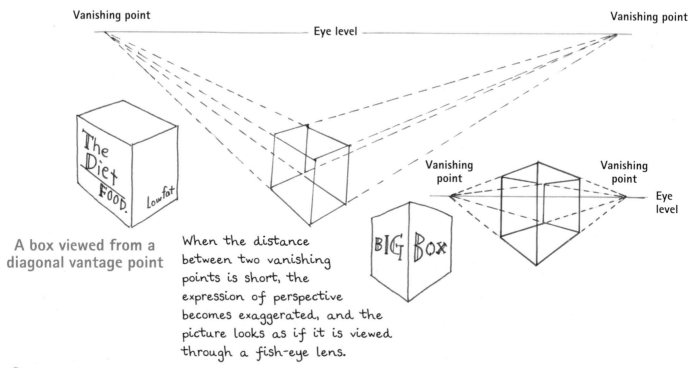

A box viewed from a diagonal vantage point

When the distance between two vanishing points is short, the expression of perspective becomes exaggerated, and the picture looks as if it is viewed through a fish-eye lens.

Three-Point Perspective

With *three-point perspective*, a vanishing point above or below the object is added in addition to the left and right vanishing points. Three-point perspective is used to create a realistic effect for a high (or low) diagonal vantage point.

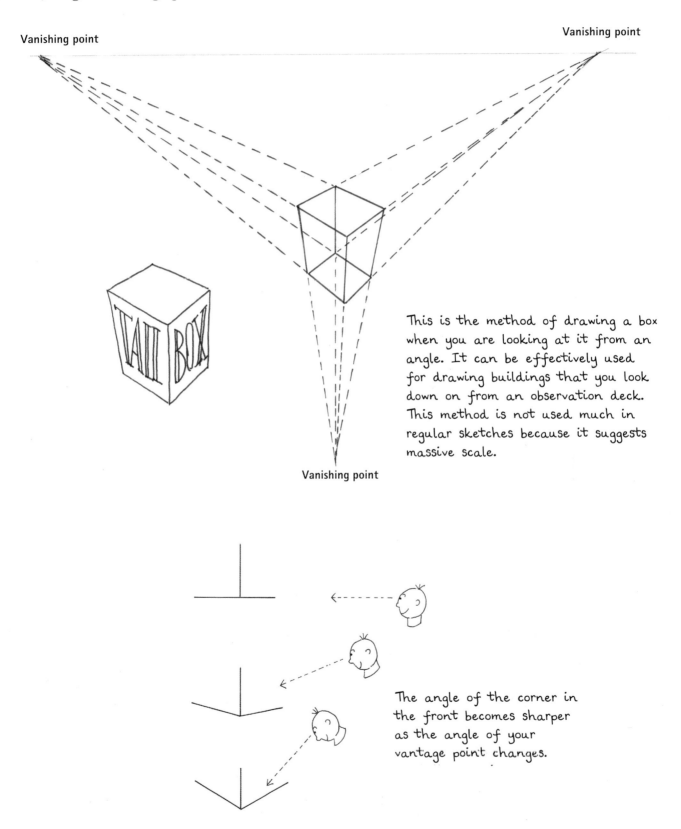

Vanishing point

Vanishing point

Vanishing point

This is the method of drawing a box when you are looking at it from an angle. It can be effectively used for drawing buildings that you look down on from an observation deck. This method is not used much in regular sketches because it suggests massive scale.

The angle of the corner in the front becomes sharper as the angle of your vantage point changes.

Let's Try Drawing a Tea Canister

Single Point Perspective: A Box Seen From the Front

1 Draw the horizon line.

Horizon line

A Tea Canister

2 Draw the front of the box.

When drawing in perspective, where should I position the horizon line?

Roughly gauge where the horizon is in relation to the height of the object you are trying to draw. At this stage, it is easier to determine this point if you hold your hand horizontally at eye height and make note of what you can see at that level (for example, a mark on the wall).

The farther away you place the object you draw, the closer the object will appear to the eye-level horizon line, and the closer you place it, the farther the object will appear to that line.

The top of tall objects will appear close to the horizon line, and the bottom will appear far from the horizon line.

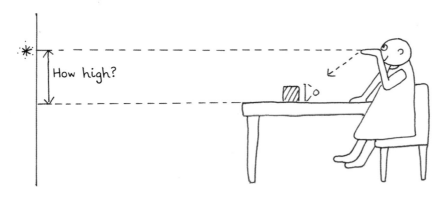

How high?

3 Stretch out the center point of the front of the box vertically, and make a mark where it hits the horizon line.

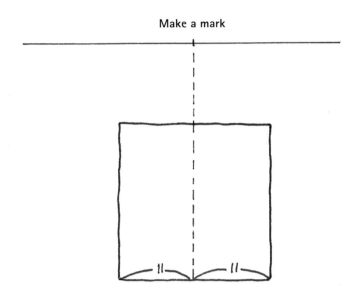

Make a mark

4 Draw lines from both upper corners of the box to the mark made on the horizon line line.

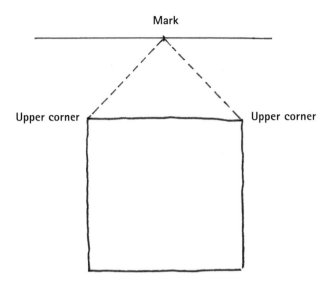

Mark

Upper corner Upper corner

5 Decide on the depth, and draw a horizontal line.

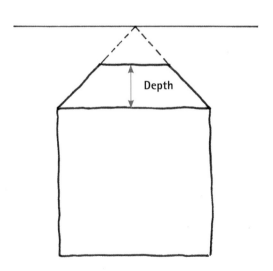

Depth

6 Draw lines to connect the opposing corners.

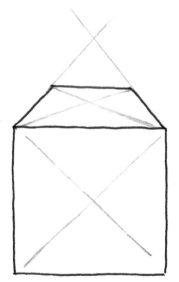

7 Draw circles whose centers appear at the
intersection of the diagonal lines.

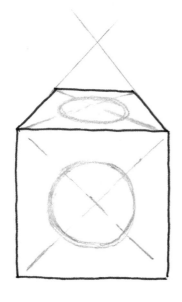

Tip for Drawing Circles

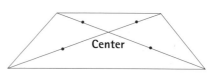

Center

Make marks at the midpoints of each segment
of the diagonal lines that cross at the center
point, and then connect the marks with
curving freehand lines.

The front face is a square, so the circle
there is a true circle, and the top side is a
trapezoid, so thet circle there is drawn as an
oval to show perspective.

8 Draw the the rim.

Because the lip of the rim is raised, the
inside is visible on the left and right, and
the back. Shade that part to emphasize the
three-dimensional effect.

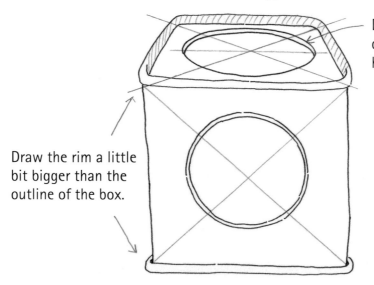

Draw the thickness
of the oval-shaped
hole in the back.

Draw the rim a little
bit bigger than the
outline of the box.

Finished

Once you have drawn the outlines, trace the necessary lines with a pen, and erase the lines you don't need with a kneaded eraser (see page 89) before applying color

The light is coming from the opposite side of the vantage point (from the back of the canister).

Depict the shadow inside the can.

If you define dark and light areas, you can make the surface appear metallic.

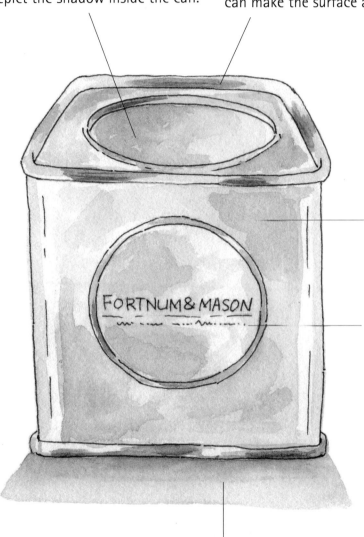

FORTNUM & MASON

Don't get too particular about the color. The key is to quickly apply a light wash.

▶ The actual canister is silver, but I have changed it to green.

Small text does not have to be drawn accurately.

Put in a shadow in the foreground.

If you draw the finishing lines freehand, the drawing will have an informal, relaxed appearance.

How to use paint ▶ page 90

Colors used

Viridian **Olive green** **Sepia**

Let's Try Drawing a Rubik's Cube

A Box Seen Diagonally: Two-Point Perspective

1 Draw the horizon line.

Horizon line

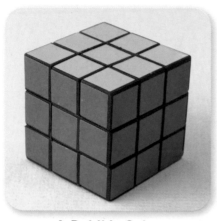

A Rubik's Cube

2 Draw the vertical line in the front of the box.

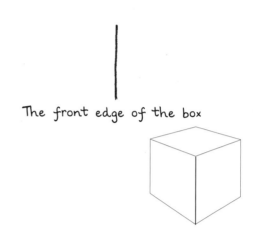

The front edge of the box

3 Draw the lines that form the two upper front edges of the box from the top of the vertical line, and mark the points where they hit the horizon line as point A and point B.

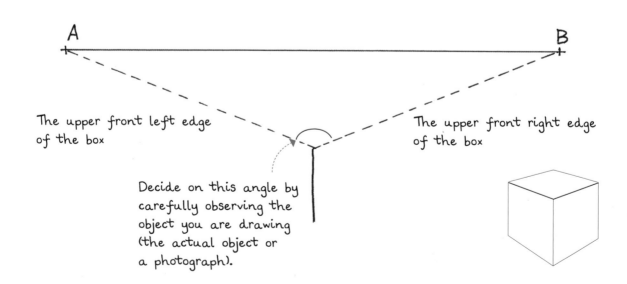

A

B

The upper front left edge of the box

The upper front right edge of the box

Decide on this angle by carefully observing the object you are drawing (the actual object or a photograph).

14

4 Draw lines from points A and B to the bottom end of the vertical line to draw the two lower front edges of the box.

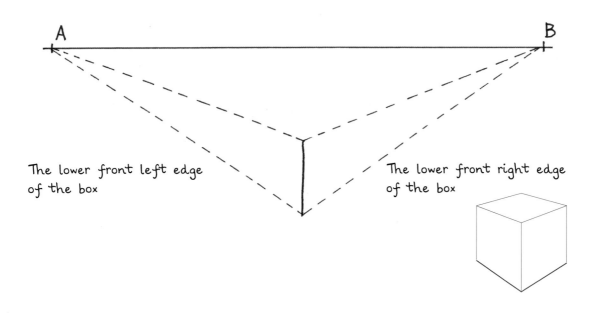

A

B

The lower front left edge of the box

The lower front right edge of the box

5 Decide on points C and D on the lines you drew in **Step 3** to indicate the ends of the upper front edges of the box that indicate the depth of the box. Draw a line from point C to point B, and a line from point D to point A.

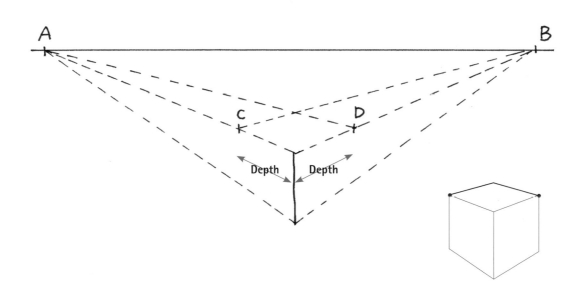

A

B

C

D

Depth Depth

6 Draw vertical lines from points C and D to the lower front edges of the cube.

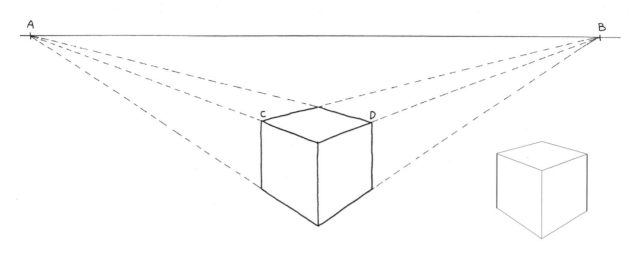

7 Draw in the colored squares.

The lines extend laterally to meet at point A and point B respectively.

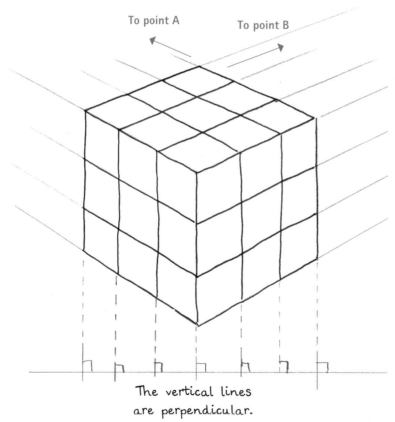

To point A To point B

The vertical lines are perpendicular.

Trace the lines lines of the object with a pen, and then erase the guide lines with a kneaded eraser.

8 Apply color to finish.

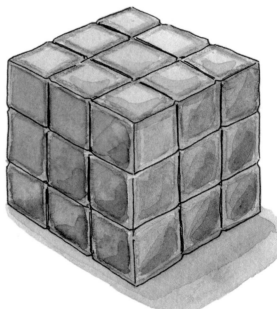

If you apply the colors from lightest to darkest (top side > left side > right side), the cube will appear more three-dimensional.

Colors use

Yellow Deep yellow Vermilion Light green Viridian Sepia

A Tea Canister Drawn in the Same Way

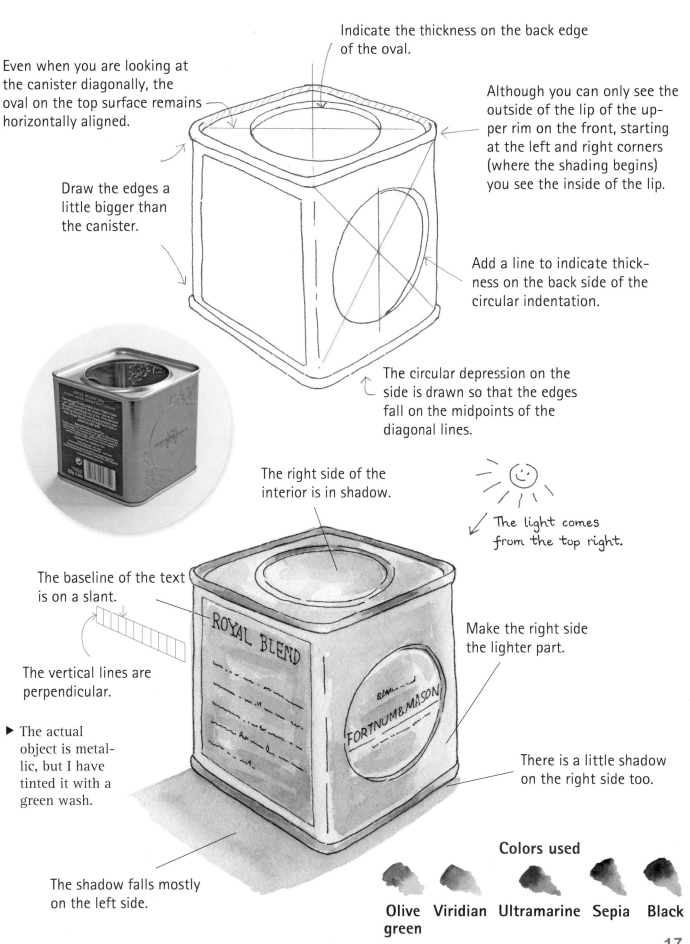

Indicate the thickness on the back edge of the oval.

Even when you are looking at the canister diagonally, the oval on the top surface remains horizontally aligned.

Although you can only see the outside of the lip of the upper rim on the front, starting at the left and right corners (where the shading begins) you see the inside of the lip.

Draw the edges a little bigger than the canister.

Add a line to indicate thickness on the back side of the circular indentation.

The circular depression on the side is drawn so that the edges fall on the midpoints of the diagonal lines.

The right side of the interior is in shadow.

The light comes from the top right.

The baseline of the text is on a slant.

ROYAL BLEND

FORTNUM & MASON

Make the right side the lighter part.

The vertical lines are perpendicular.

▶ The actual object is metallic, but I have tinted it with a green wash.

There is a little shadow on the right side too.

The shadow falls mostly on the left side.

Colors used

Olive green Viridian Ultramarine Sepia Black

17

Using Light and Shadow to Show Three-dimensionality

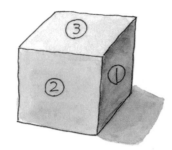

When you have a box-shaped object with flat surfaces, make the light and shadows of the sides you can see logical.

Dark **❶** — Medium **❷** — Light **❸**

The side where a shadow is cast on the surface the box rests on is the darkest side.

When you have a sphere or cylindrical object with curved sides, create light and dark areas with smooth transitions.

If you add a subtle highlight adjacent to the nearest edge of the shaded side, the object will look three-dimensional.

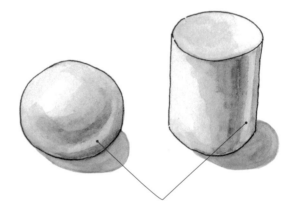

Make a subtle highlight.

Do you want to draw a box? A sphere? A cylinder? Which shape does your object most closely fit?

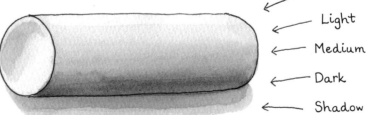

White
Light
Medium
Dark
Shadow

A cylinder lying on its side goes from
white → light → medium → dark → shadow

If you shade an object like this as a gradation, it will appear three-dimensional (adding a subtle hightlight in the shaded area will strengthen this effect).

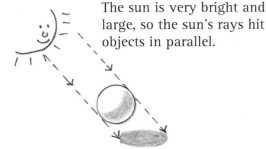

The sun is very bright and large, so the sun's rays hit objects in parallel.

When a small, nearby light source such as a candle or a light bulb casts light on an object, the "spotlight" illumination spreads out, enlarging the shadow.

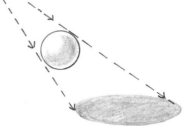

The Height of the Light Source: The Sun in the Morning and Evening

The length of the shadows changes depending on the height of the light source.

When the light source is low, such as with an evening sun, the shadows become long.

! When you want to illustrate an evening or morning scene, draw elongated shadows.

The Height of the Light Source: The Midsummer Sun During the Day

Key Point!

When you are painting in shadows with water-colors, if you put them in too darkly it will give an impression of a strong light (such as a spotlight) hitting the object, and the lighting in the picture will look too stark. Add shadows lightly and gently.

Glaring Glaring

Jump!

A glaring sun shines from directly above. In cases like this, draw a small shadow directly below the object.

When the object is separated from the ground, the shadow becomes separated too.

Box Perspective: Commonly Made Errors

Pattern A

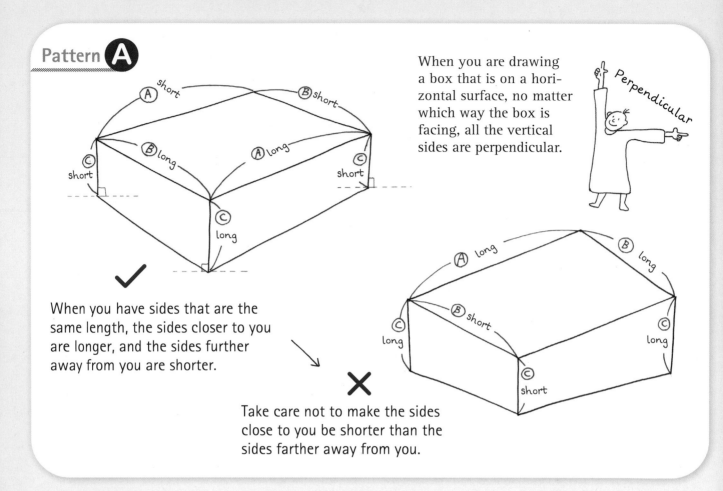

When you are drawing a box that is on a horizontal surface, no matter which way the box is facing, all the vertical sides are perpendicular.

Perpendicular

When you have sides that are the same length, the sides closer to you are longer, and the sides further away from you are shorter.

Take care not to make the sides close to you be shorter than the sides farther away from you.

Pattern B

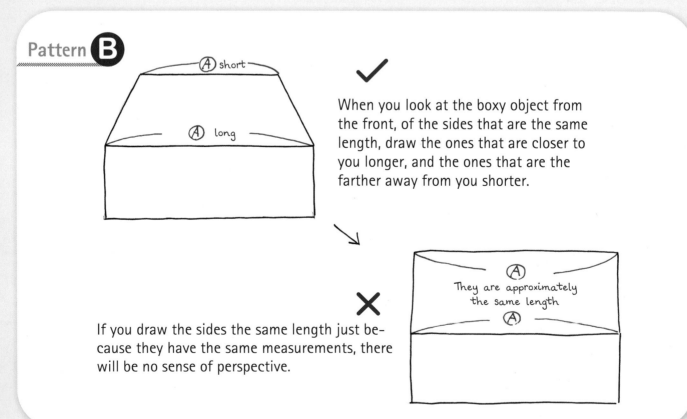

When you look at the boxy object from the front, of the sides that are the same length, draw the ones that are closer to you longer, and the ones that are the farther away from you shorter.

If you draw the sides the same length just because they have the same measurements, there will be no sense of perspective.

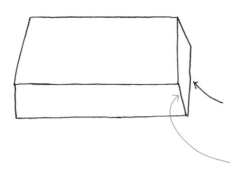

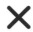

At this angle the left and right sides should not be visible, but the right side is drawn. Perhaps the artist tilted their head and saw the right side, or simply tried to force a three-dimensional effect.

▶ The vertical edges of a box that is placed on a flat surface are perpendicular to the surface. In this example drawing, the vertical edge is not perpendicular, so the side surface had to be drawn in.

Pattern **D** Circle on a Box

How to draw a circular label or an opening on top of a box that is placed on a horizontal surface.

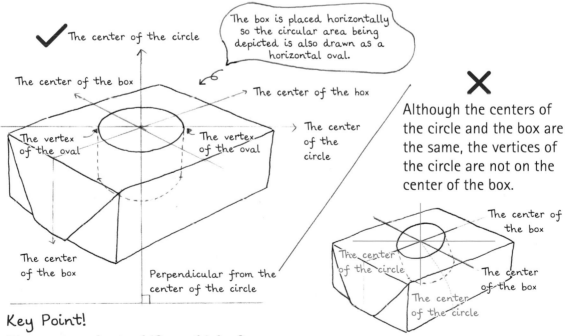

✔ The center of the circle

The center of the box

The box is placed horizontally so the circular area being depicted is also drawn as a horizontal oval.

The center of the box

The center of the box

The vertex of the oval

The vertex of the oval

The center of the circle

The center of the box

Perpendicular from the center of the circle

✗ Although the centers of the circle and the box are the same, the vertices of the circle are not on the center of the box.

The center of the box

The center of the circle

The center of the box

The center of the circle

Key Point!
It's easy to understand if you think of it as a cylinder embedded in the box.

The vertexes of the circle overlap the center lines of the circle.

Toy Cars: Trim a Box Shape

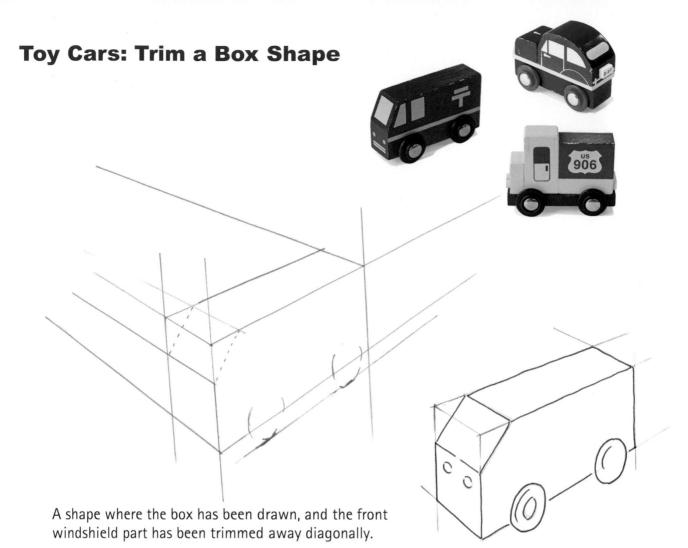

A shape where the box has been drawn, and the front windshield part has been trimmed away diagonally.

Trim away to reveal the hood and the truck bed.

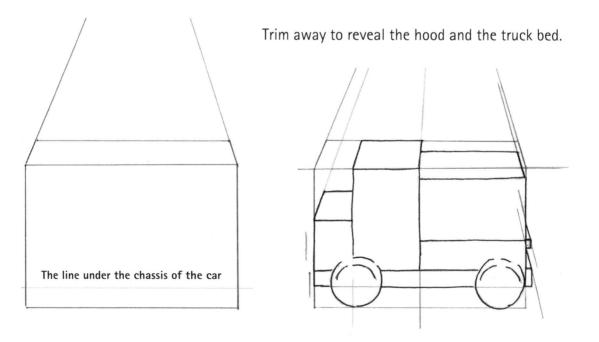

The line under the chassis of the car

Rounded shapes are just modified boxes.

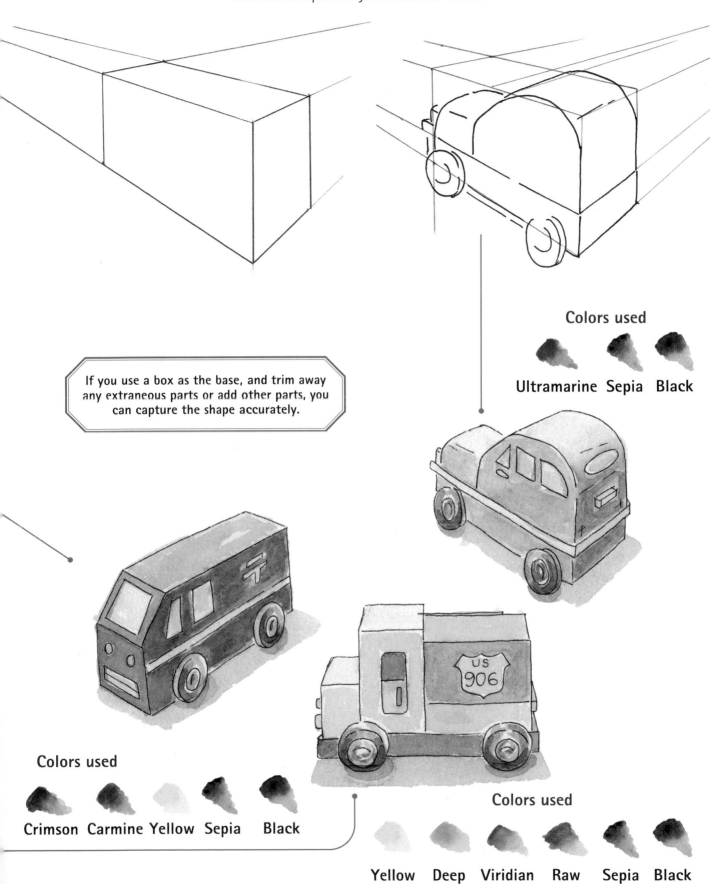

If you use a box as the base, and trim away any extraneous parts or add other parts, you can capture the shape accurately.

Colors used

Ultramarine Sepia Black

Colors used

Crimson Carmine Yellow Sepia Black

Colors used

Yellow Deep yellow Viridian Raw umber Sepia Black

Height and Orientation

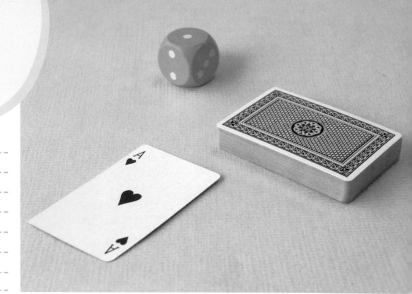

Even when you have straight-edged objects with different hights and directions, when you are looking at them from the same point of view, the extensions of their parallel lines hit the same horizon line.

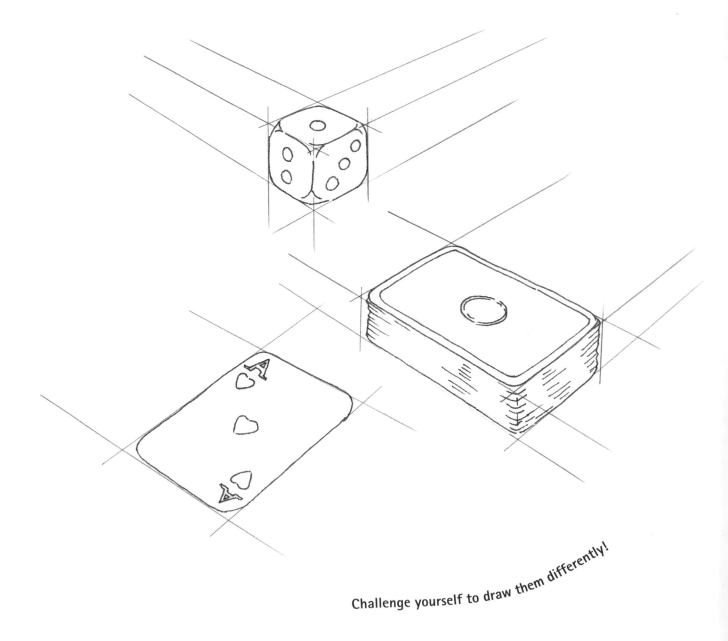

Challenge yourself to draw them differently!

Horizon line

Objects viewed from the same vantage point have lines that converge on the same horizon line when extended.

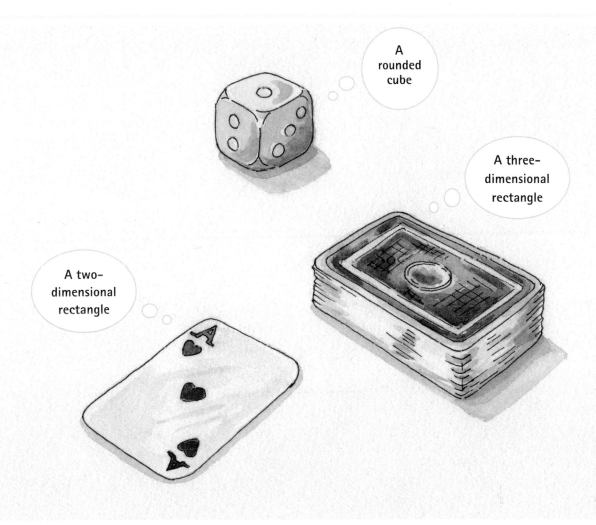

A rounded cube

A three-dimensional rectangle

A two-dimensional rectangle

Colors used

| Yellow | Deep yellow | Crimson | Turquoise blue | Ultramarine | Raw umber | Black |

Using the Box Shape

Even objects that do not look like boxes at first glance can be drawn easily and accurately by adapting the box shape.

■ A Folded Shirt

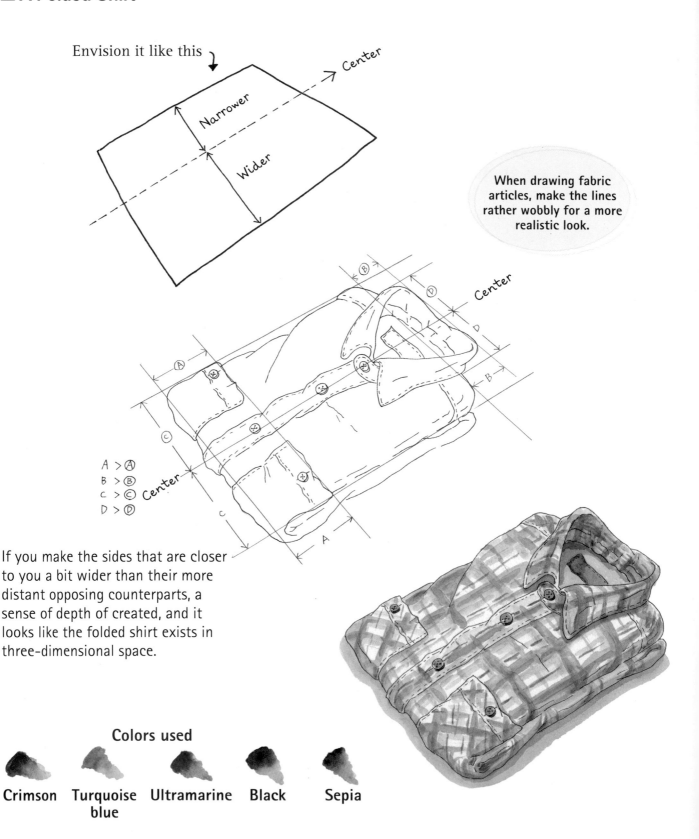

Envision it like this

Center

Narrower

Wider

When drawing fabric articles, make the lines rather wobbly for a more realistic look.

Center

A > Ⓐ
B > Ⓑ
C > Ⓒ
D > Ⓓ

Center

If you make the sides that are closer to you a bit wider than their more distant opposing counterparts, a sense of depth of created, and it looks like the folded shirt exists in three-dimensional space.

Colors used

Crimson Turquoise Ultramarine Black Sepia
 blue

■ Glasses

Let's try drawing these glasses while envisioning them being in a box.

Center

Wider

Narrower

Side (temple)

Fit them into a box shape as you draw the outline.

Front

With most glasses, the width of the front and the sides (the temples) are about the same. You can understand this easily if you fold up the glasses.

Add subtle curves to the sides (the temples).

The part that goes over the ears can be difficult depending on the angle of the curve, so draw them without getting too hung up on the shape.

If you add a few lines to indicate reflections on the lenses, it will suggest the appearance of transparency.

Colors used

Ultramarine Black Sepia

Gallery of Box Shapes

Building blocks are perfect for practicing capturing shapes accurately! Try combining several blocks placed in different orientations and drawing them.

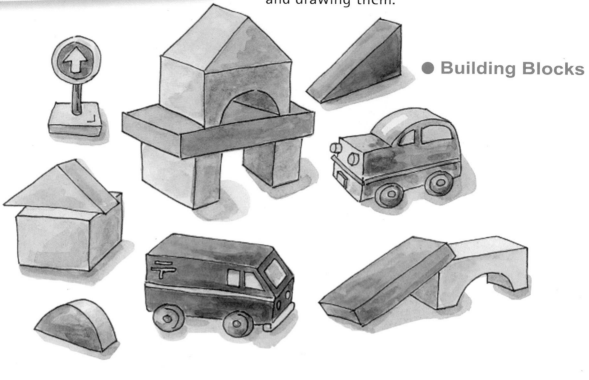

● **Building Blocks**

● **Geta Sandals**

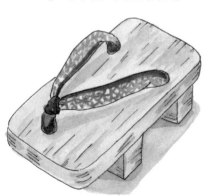

Focus on the way that the base and the "teeth" (the stilts) are perpendicular!

● **A Juice Carton**

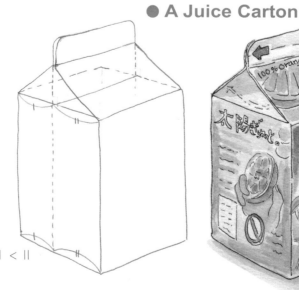

A shape where the top of the box is closed in a triangular shape. The vertex of the triangle connects with the center of the box in one straight line.

A chocolate bar is a box shape with regular indentations. Because light is hitting it from the back left side, the cast shadow is on the near right side, and the left back sides of the indentations are dark.

● **Chocolate Bar**

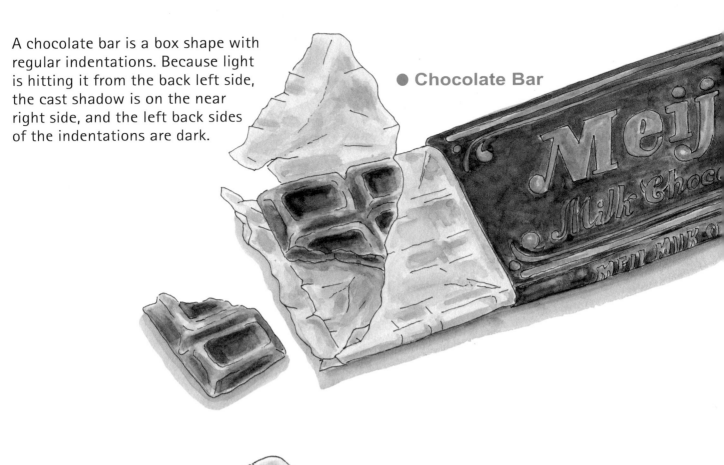

● **Food Packages**

Don't be distracted by the pictures or text on the boxes—or the opened part! The bases are simple boxes, so align the text or pictures along the surfaces of the boxes.

PART TWO
Drawing Objects with Cylinders

Let's try drawing various objects with a cylinder as the base shape!

Colors used

Olive green **Viridian** **Ultramarine** **Black** **Sepia**

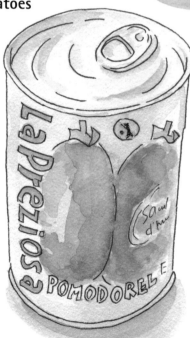

Candle

Instructions ▶ page 33

Balsamic vinegar bottle

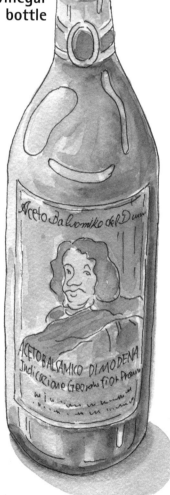

Can of tomatoes

Instructions ▶ page 34

Instructions ▶ page 40

Colors used

Yellow **Deep yellow** **Vermilion** **Carmine** **Crimson**

Viridian **Olive green** **Ultramarine** **Yellow ochre** **Sepia**

Colors used

Crimson **Jaune brillant** **Greenish yellow** **Olive green** **Deep yellow**

Yellow ochre **Raw umber** **Burnt sienna** **Sepia** **Black**

30

Cylinder Vantage Points—Cross Sections

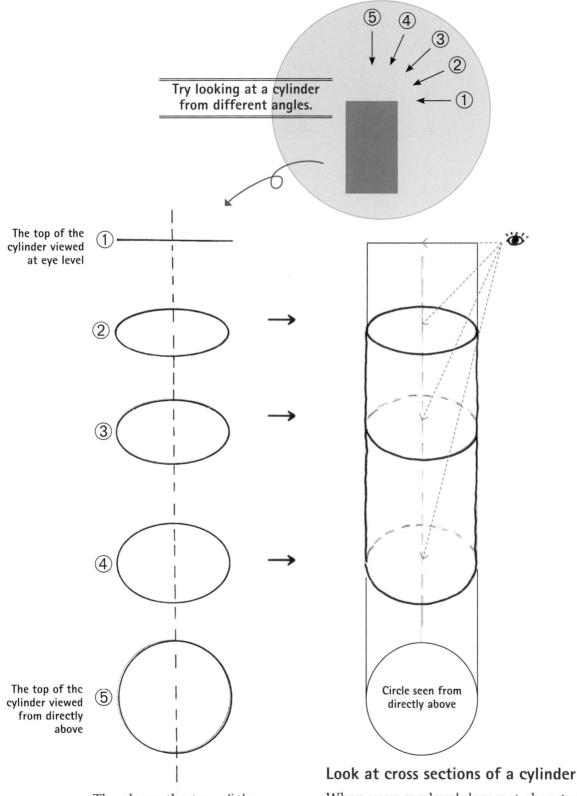

Try looking at a cylinder from different angles.

The top of the cylinder viewed at eye level ①

②

③

④

The top of the cylinder viewed from directly above ⑤

Circle seen from directly above

The closer the top of the cylinder comes to eye level, the more acutely oval the top appears.

Look at cross sections of a cylinder

When your eye level does not change while you are observing a cylinder, the same principle from the example to the left is in effect. The cross-section shapes change depending on your vantage point.

Draw a Basic Cylinder

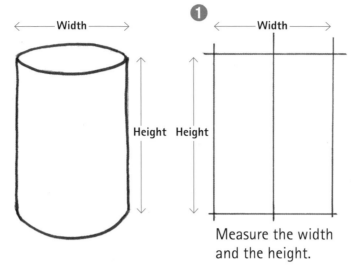

❶ Measure the width and the height.

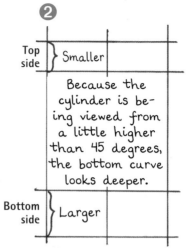

❷ Measure the thicknesses of the top and bottom sides (pay attention to the sides you can't see too).

Top side } Smaller

Because the cylinder is being viewed from a little higher than 45 degrees, the bottom curve looks deeper.

Bottom side } Larger

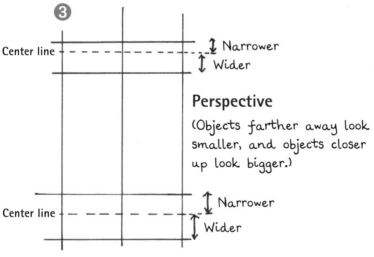

❸ Center line

↕ Narrower
↕ Wider

Perspective

(Objects farther away look smaller, and objects closer up look bigger.)

Center line

↕ Narrower
↕ Wider

Draw the center lines of the ovals. Make the nearer side a bit wider (farther away, smaller; closer, wider).

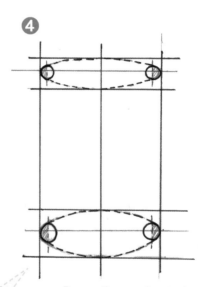

❹ Draw the ovals at the top and bottom ends.

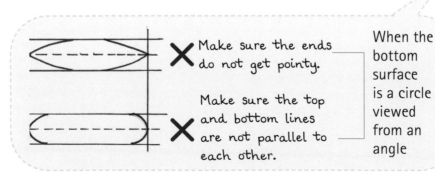

✗ Make sure the ends do not get pointy.

✗ Make sure the top and bottom lines are not parallel to each other.

When the bottom surface is a circle viewed from an angle

▶ The height of your eye level changes the same amount as the height of the cylinder. Because the bottom surface is seen from a higher vantage point than the top surface, more of the bottom surface is visible.

Let's Use the Basic Cylinder to Draw a Candle

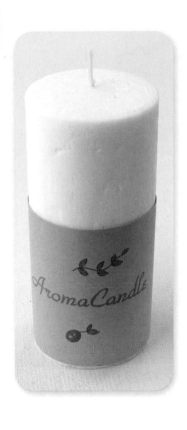

1 Determine the positions.

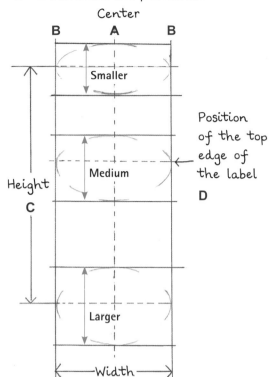

A Draw the center line.

B Draw the two sides of the cylinder shape so that they are equidistant from the center line.

C Measure approximately how many times the width of the cylinder it is high to determine the height.

D Determine the height of the label the same way.

2 Draw the curves of the ovals while considering the hidden portions, and decide on the positions of the text.

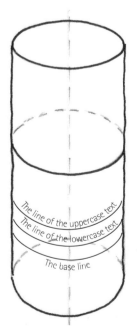

3 Draw the text, illustrations and the wick.

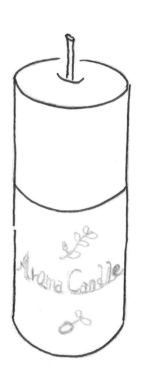

4 Add color to finish (the key is not to add too much).

Paint dark sky blue on the left side.

Make the right side darker.

Add a cast shadow on the right side.

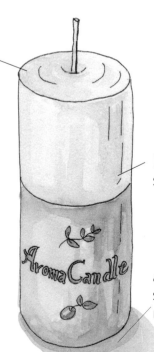

Let's Try Drawing a Can of Tomatoes

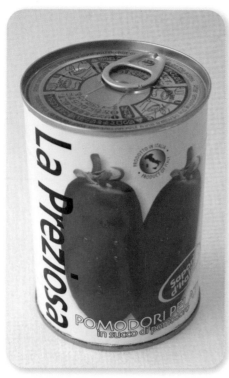

Canned tomatoes

1 Since the can is being viewed from slightly above eye level, draw a cylinder that is slightly tapered toward the bottom.

Pencil

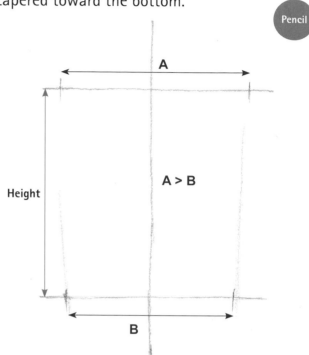

A

Height

A > B

B

2 Decide on the approximate positions of the top and bottom ovals.

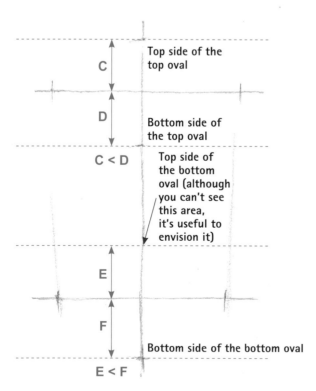

C

Top side of the top oval

D

Bottom side of the top oval

C < D

Top side of the bottom oval (although you can't see this area, it's useful to envision it)

E

F

Bottom side of the bottom oval

E < F

3 Using the upper, lower, left and right marks as guides, draw the ovals freehand.

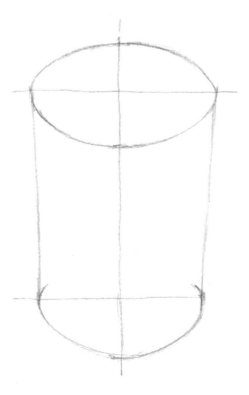

4 Draw the rim of the can and the pull tab.

Draw the pull tab as if it is oriented toward the center of the oval of the cylinder.

The pull top looks more substantial if you add thickness to it (the shaded part).

The thickness of the rim sticks out a little.

5 Add the text and illustrations on the sides.

Simplify the tomato illustrations, and leave out the text and illustrations on the top.

Draw the text following the curve of the sides.

Kneaded eraser

Erase the supplemental or stray lines with a kneaded eraser, and lighten up the underdrawing.

Common Mistakes Made with the Text on the Sides

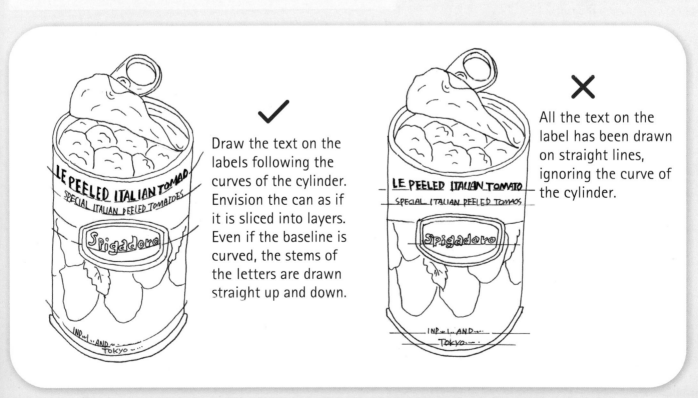

✓ Draw the text on the labels following the curves of the cylinder. Envision the can as if it is sliced into layers. Even if the baseline is curved, the stems of the letters are drawn straight up and down.

✕ All the text on the label has been drawn on straight lines, ignoring the curve of the cylinder.

6 Draw with a pen.

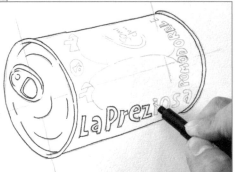

Trace the pencil lines with a pen. The trick is to turn the paper so you can move the pen in the direction that is easiest for you to draw.

You can start drawing from anywhere, but it's easier to draw by starting with the outline and then going to the detailed parts.

7 Erase with a kneaded eraser.

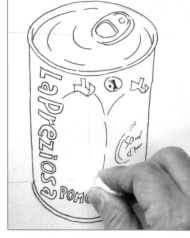

When you have finished drawing with the pen, erase the pencil lines by picking them up with the kneaded eraser.

8 Paint the letters. **Ultramarine**

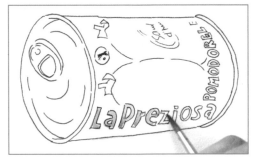

Start painting wherever you like. In this example, I liked the text so I started there.

9 Paint the tomatoes.

Vermilion **Deep yellow**

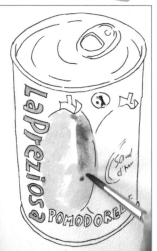

After painting on layers of red, add yellow.

10 Paint the top side.

Olive green **Yellow ochre**

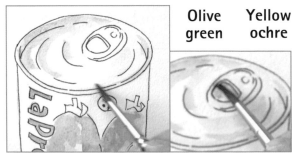

11 Put green on the calyxes of the tomatoes.

 Viridian

Product of Italy seal of authenticity

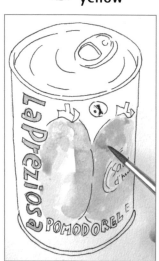

12 Paint the logo.

Yellow

13 Layer more red on the tomatoes.

> Fill in the red gradient on the left side of the seal.

Carmine

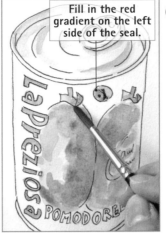

14 Add shading to the can.

Ultramarine

Because the light is hitting the can from the far side, make the center a bit darker than the edges.

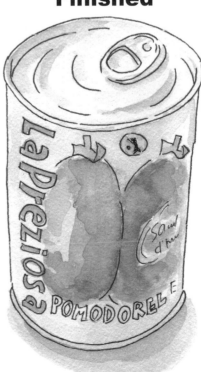

Add a diluted layer of blue to the white part of the can label, avoiding the tomatoes. You don't have to paint it in precisely.

Crimson

15 Add a cast shadow.

Sepia

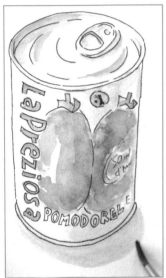

Add a shadow starting from the bottom of the can, spreading it outward.

16 Add more red to the tomatoes.

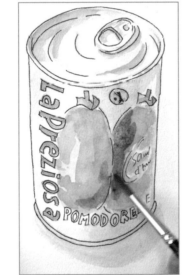

As you can see from the tomatoes, color is built up in layers.

17 Layer on the shadow.

Sepia

If you stroke the tip of the brush along the bottom rim of the can to put in another layer of shadow, it will look like the can is firmly in contact with the surface.

Finished

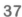

How to Differentiate Your Drawings

Baumkuchen and Donut

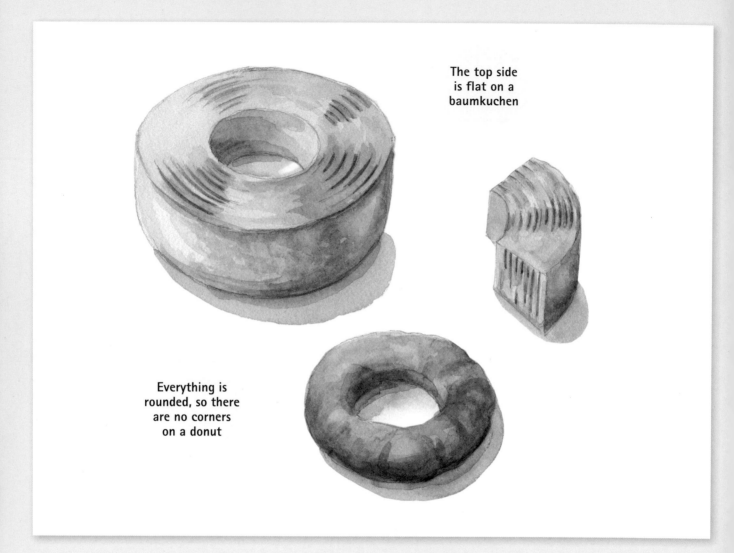

The top side is flat on a baumkuchen

Everything is rounded, so there are no corners on a donut

Donut

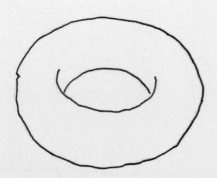

A donut has no sharp angles, so just draw the front side of the outline of the hole to give the opening the rounded appearance of a torus.

Colors used

Yellow ochre Burnt sienna Sepia

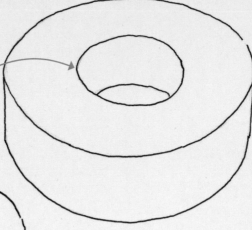

A slice of baumkuchen (a rolled cake with a hole in the middle) has 90 degree angles, so draw the complete outline of the hole to define it.

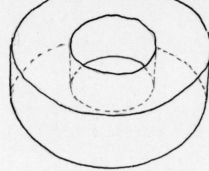

Draw the outline of the bottom of the hole that you can see too.

Colors used

| Yellow ochre | Raw umber | Burnt umber | Burnt sienna | Sepia |

A slice of a baumkuchen is easy to envision if you draw the cut lines into a whole slice with a pencil.

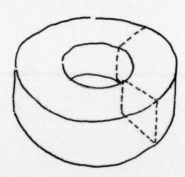

Similar, but...

A roll of toilet paper, just like a slice of baumkuchen, is a cylindrical shape with a hole in the middle, but because it is taller, when it is viewed from the same vantage point as the baumkuchen, the bottom outline of the hole cannot be seen.

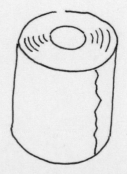

Let's Try Drawing a Bottle of Balsamic Vinegar

1 Draw a rectangle and determine the height and width of the bottle.

Pencil

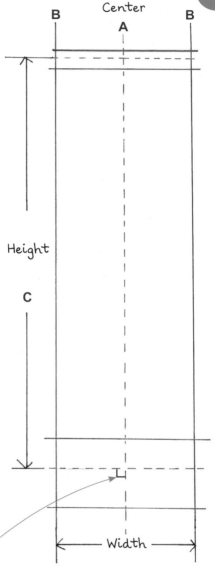

2 Add the guide points for the curves.

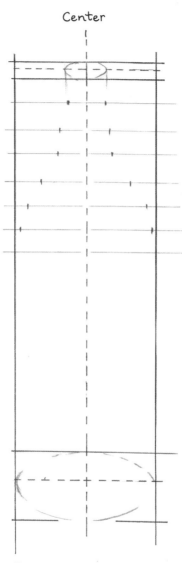

Draw 6 to 7 horizontal lines where the bottle curves, and add guide points that are equidistant to the center line, following the curve of the bottle.

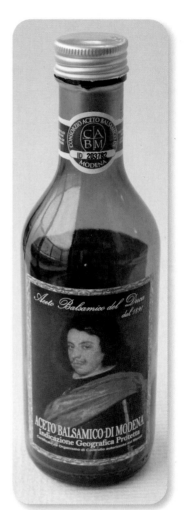

Balsamic Vinegar

A Draw the vertical centerline.

B Draw the bottom oval centerline perpendicular to the vertical center line. Make the outer edges equidistant from the vertical centerline. (Although the bottle does look a bit smaller on the bottom when viewed from slightly above, don't worry about that here.)

C Measure approximately how many times wide of the bottle it is high, to determine the height.

Key Point!

If you draw it so that the vertical center line and the center lines of the bottom oval and the horizontal center line are at right angles, it will look like the bottle is standing upright.

40

3 Connect the points along the curves of the neck.

4 Draw in the details.

5 Draw the label.

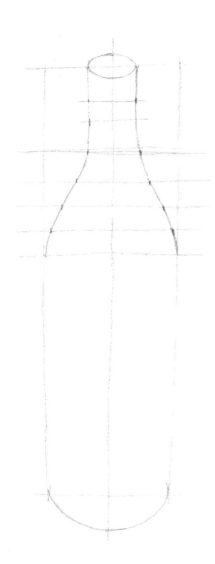

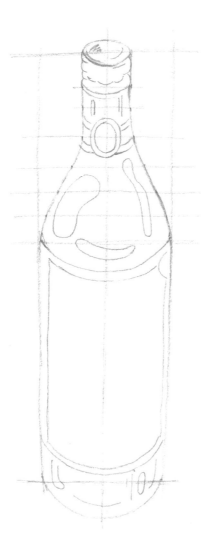

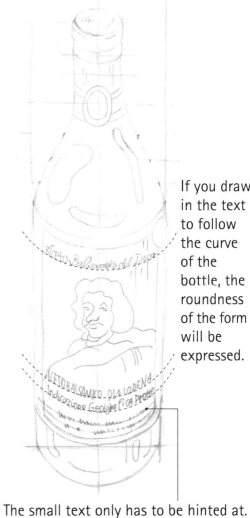

If you draw in the text to follow the curve of the bottle, the roundness of the form will be expressed.

The small text only has to be hinted at.

Connect the guide points with a smooth curve so that the left and right sides look about the same.

Observe the bottle carefully, and draw in the details. Draw organic shapes to define where the highlights appear.

The figure on the bottle doesn't have to be drawn accurately. As long as it looks like a characature of an Italian nobleman, it's fine!

Erase the guidelines and stray marks with a kneaded eraser, and make the underdrawing lighter.

Kneaded eraser

6 Trace with a pen.

Pen

Trace the pencil lines with a pen. The key is to turn the paper in the direction that is easier for you to draw. It is easier to draw vertical lines from top to bottom, and horizontal lines from left to right (if you are left-handed, from right to left).

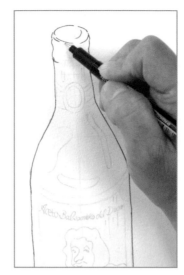

After the outline is drawn, add in the details.

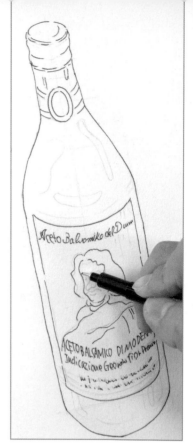

Draw the label.

The Pen Drawing is Finished

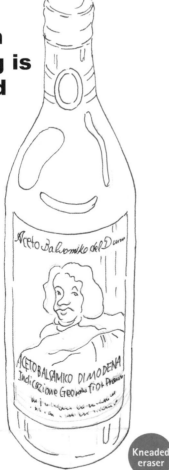

Erase the pencil lines.

Kneaded eraser

7 Paint in the shading of the cap.

Paint

Yellow ochre **Raw umber**

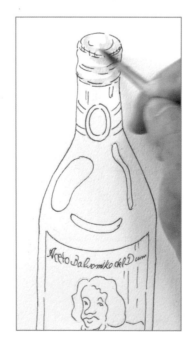

8 Paint the band of the label.

Crimson **Burnt sienna**

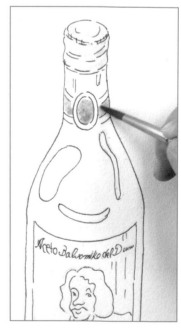

You don't have to paint too precisely. Just dot on the color.

9 Paint glass of the bottle. **Greenish yellow** **Olive green**

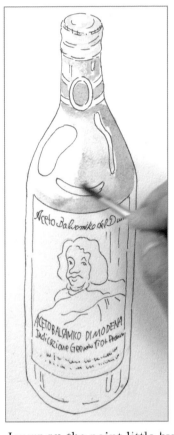 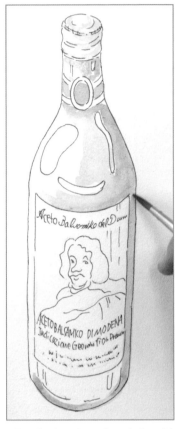 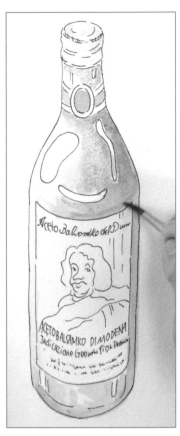

Layer on the paint little by little. By darkening the right side, a sense of three-dimensionality is created. If you leave the parts where the light is reflected on the bottle white, and then add a light amount of color around the highlights, the bottle will look like it's glossy.

10 Paint the border of the large label.

Deep yellow **Yellow ochre**

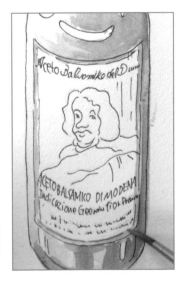

11 Paint the picture on the label.

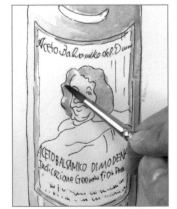

Paint the hair and all the clothing (except for the sash) with dilute black. (Opaque black appears in the reference photo, but using that here would look too heavy.)

 Black

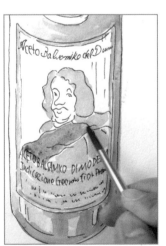

Paint the sash.

 Crimson **Burnt sienna**

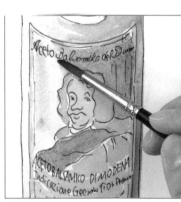

Paint the face, and then paint in the background with medium black.

 Jaune brillant **Sepia**

 Black

43

12 Paint the cap.

Yellow ochre **Greenish yellow**

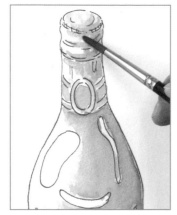

Add a thin layer of color from the side where you added the shading.

13 Add color to the bottle and the upper label.

Olive green **Sepia** **Crimson** **Burnt sienna**

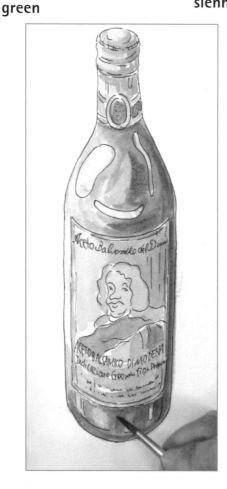

14 Add color to the figure on the large label.

Sepia **Black**

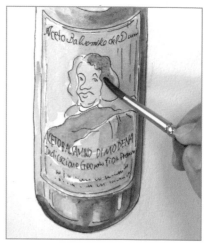

Adjust the color while maintaining the balance.

15 Add the cast shadow.

Sepia

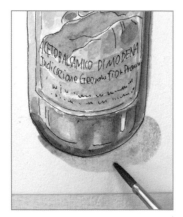

Paint in the shadow from the bottom edge of the bottle outward. If you let it dry and then add another layer next to the bottom edge of the bottle, it will look like it is firmly in contact with the surface.

16 Adjust the colors of the figure.

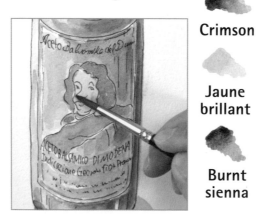

Crimson

Jaune brillant

Burnt sienna

Add warmth to the cheeks of the figure, and add red to the sash too.

Finished

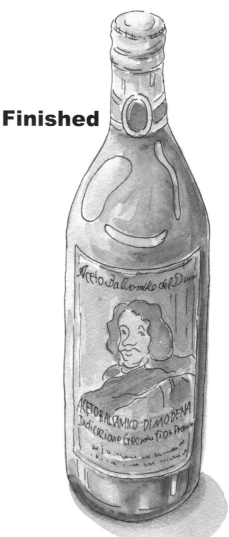

Various Bottles and Jars

▼ A jar that narrows at the bottom

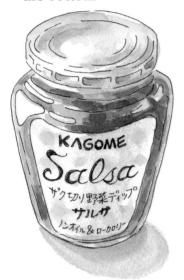

Colors used

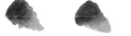

◀ A bottle with rounded edges

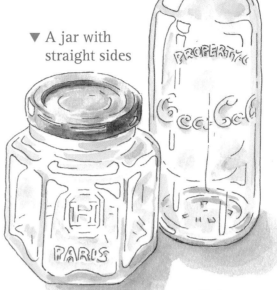

▼ A jar with straight sides

Viridian

Greenish yellow

Sepia

Colors used

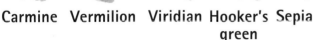

Carmine Vermilion Viridian Hooker's green Sepia

Colors used

Crimson Carmine Viridian Hooker's green Sepia

The curve of a pencil leaning to the back side is like a convex arc.

This line indicates the thickness of the glass.

This line makes it clear that glass is in the front.

You can't see the bottoms of pencils that are leaning forward.

You can see the bottoms of pencils that are leaning backward.

The curve of a pencil leaning forward is like a concave arc.

Leave areas where the curve of the jar changes white to express the reflection of the light. Observe how refraction distorts the shapes.

After everything else is fully dry, add a quick wash of very diluted sky blue in curving strokes.

Colors used

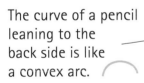

Crimson Carmine Vermilion Deep yellow

Viridian Olive green Ultramarine

Turquoise blue Magenta Opera Sepia

A transparent jar

Although this may look complicated and difficult, as long as you have a good grasp on depicting cylindrical shapes, it will be fine!

45

How to Draw a Cylinder on Its Side

How the ovals look depending on the position of the cylinder

Front

When seen from the front, the cylinder is basically a rectangle.

Gradually moving to the left

Gradually moving to the right

The more the cylinder moves to the left or right, the more closely the oval resembles a circle.

How the ovals look depending on the orientation of the cylinder

The vertical center line of the oval is perpendicular to a line parallel to the horizon.

The more the cylinder is rotated, the smaller the angle between the center line of the oval and a line parallel to the horizon becomes.

If you draw the curves so that the center line of the side is at the vertex of the oval, you can draw it realistically.

Because the cylinder is being viewed from a high angle, a little bit of the side opposite the vertex of the oval can be seen.

The face of the cylinder can only be seen between the tangent points.

This is not the vertex.

This is the vertex.

The face of the cylinder between the tangent point and the point where the vertex meets the bottom of the oval cannot be seen.

A Cylinder on Its Side: Common Errors

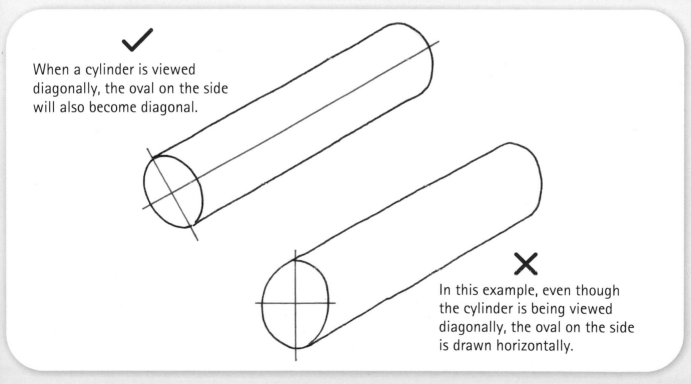

When a cylinder is viewed diagonally, the oval on the side will also become diagonal.

In this example, even though the cylinder is being viewed diagonally, the oval on the side is drawn horizontally.

Using a Cylinder on Its Side

■ A Roll of Candy

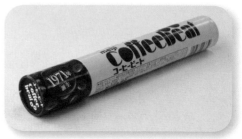

A tube of Coffee Beat candies.

If the cylinder is drawn using a box as the base, a gap is created at the corners of the box, so you can see that the edges of the box and the outline of the cylinder are not the same.

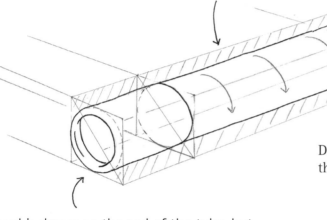

Draw the text on the package following the curves of the sides of the cylinder.

An oval is drawn on the end of the tube, but the thickness of the lid (the dotted line part) is hidden, so do not draw it.

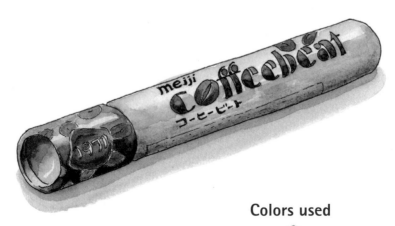

Colors used

Crimson Carmine Yellow ochre Burnt umber Burnt sienna Sepia Black

■ A Hammer

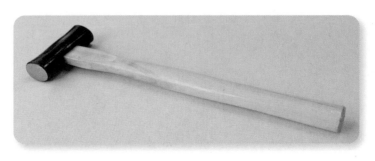

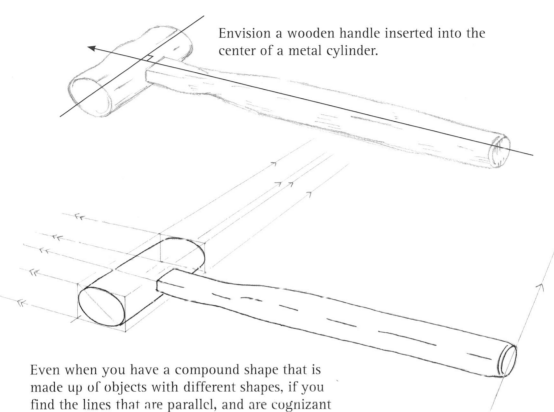

Envision a wooden handle inserted into the center of a metal cylinder.

Even when you have a compound shape that is made up of objects with different shapes, if you find the lines that are parallel, and are cognizant of the way that they will meet at one point on the horizon line as you draw them, a sense of perspective is created.

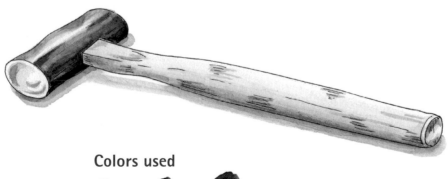

Colors used

Yellow ochre **Raw umber** **Sepia** **Black**

■ A Folded Umbrella

Let's draw a folded umbrella using a laid down cylinder as the base.

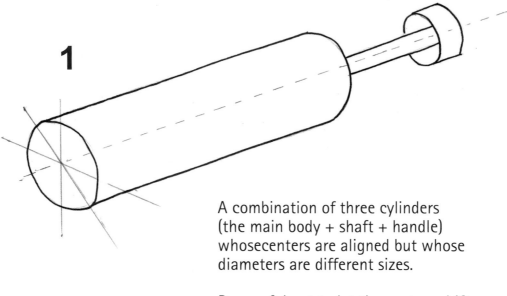

1

A combination of three cylinders (the main body + shaft + handle) whosecenters are aligned but whose diameters are different sizes.

Be careful not to let the centers shift out of alignment.

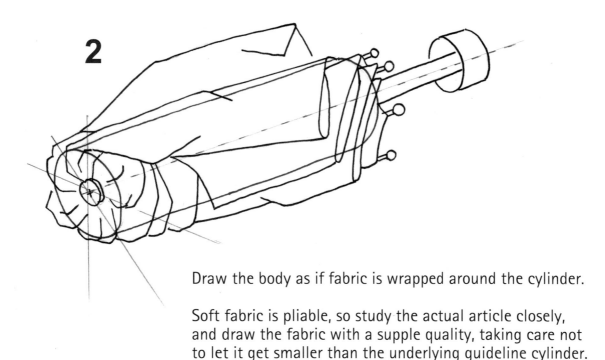

2

Draw the body as if fabric is wrapped around the cylinder.

Soft fabric is pliable, so study the actual article closely, and draw the fabric with a supple quality, taking care not to let it get smaller than the underlying guideline cylinder.

3

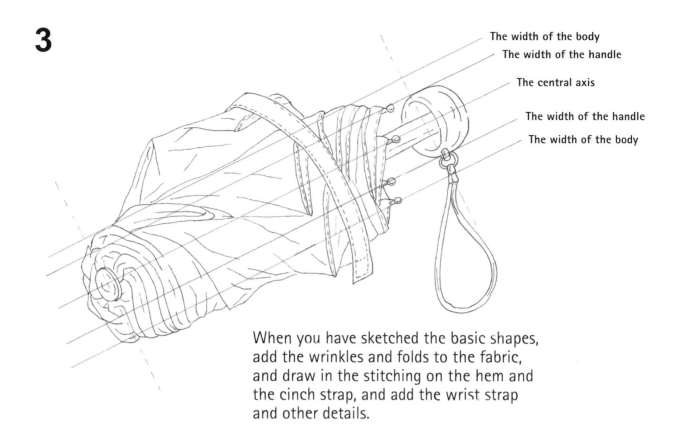

The width of the body
The width of the handle
The central axis
The width of the handle
The width of the body

When you have sketched the basic shapes, add the wrinkles and folds to the fabric, and draw in the stitching on the hem and the cinch strap, and add the wrist strap and other details.

4

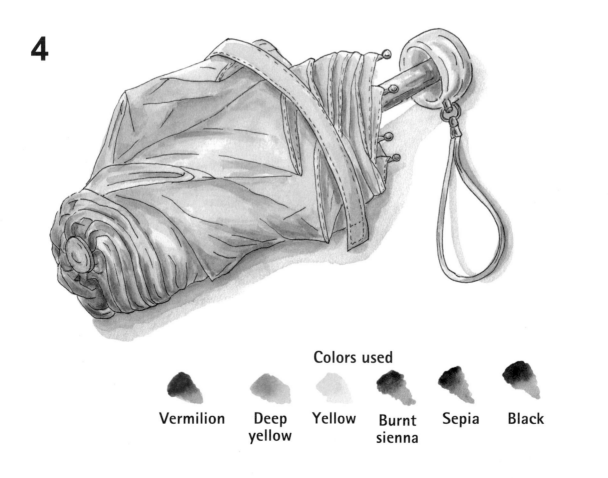

Colors used

Vermilion Deep yellow Yellow Burnt sienna Sepia Black

■ A Toothbrush Set

Key Points

▶ The bottom of the toothpaste tube is wider than the cap

▶ Capture the bristles of the toothbrush as one unit

▶ The toothbrush in the cup is leaning and in contact with the side of the cup

▶ The bottom of the cup and the bottom side of the toothpaste tube look as though they are resting on the same surface

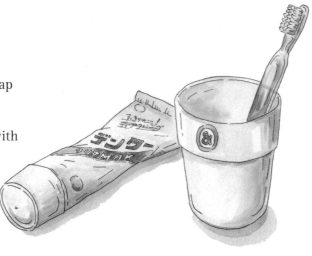

Colors used

Yellow Viridian Hooker's Ultramarine Magenta Opera
 green

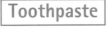
Toothpaste

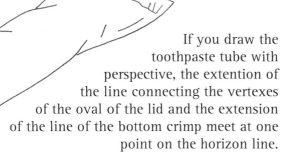

To the horizon line

To the horizon line

If you draw the toothpaste tube with perspective, the extention of the line connecting the vertexes of the oval of the lid and the extension of the line of the bottom crimp meet at one point on the horizon line.

Flattened and rolled

The tube is a cylinder with the bottom end squashed flat and crimped, so if you draw the bottom part wider than the diameter of the lid, it will look more like a tube of toothpaste.

Toothbrush

Envision a small box (like a piece of caramel) on top of the handle.

Draw the bristles as one bundle.

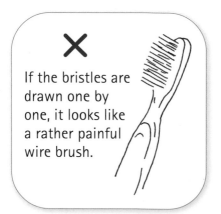

✕

If the bristles are drawn one by one, it looks like a rather painful wire brush.

Shadows Created on a Cylindrical Shape

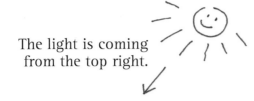

The light is coming from the top right.

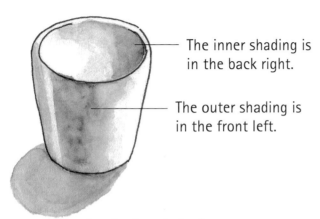

The inner shading is in the back right.

The outer shading is in the front left.

The shadow is in front, to the left.

The light is coming from the top left.

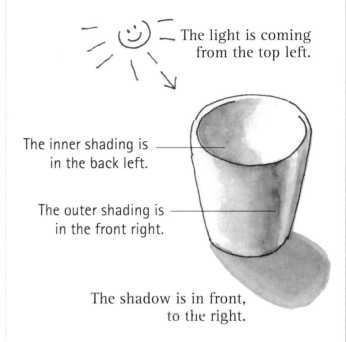

The inner shading is in the back left.

The outer shading is in the front right.

The shadow is in front, to the right.

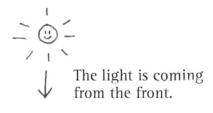

The light is coming from the front.

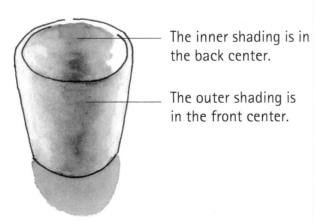

The inner shading is in the back center.

The outer shading is in the front center.

The shadow is in the front.

The light is coming from behind the person drawing.

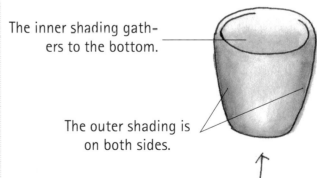

The inner shading gathers to the bottom.

The outer shading is on both sides.

The shadow on the table cannot be seen. If this creates ambiguities in your drawing, try changing your vantage point.

The Regularity of Flower Shapes

Flowers, although existing in nature, have very regular shapes. By observing the shapes of flowers carefully, you will become able to draw them easily.

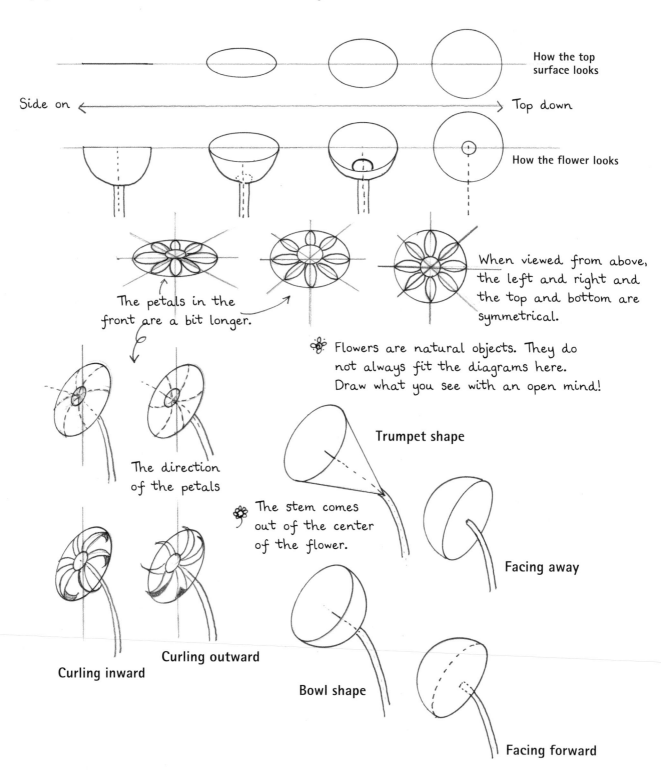

How the top surface looks

Side on ⟵⟶ Top down

How the flower looks

The petals in the front are a bit longer.

When viewed from above, the left and right and the top and bottom are symmetrical.

✿ Flowers are natural objects. They do not always fit the diagrams here. Draw what you see with an open mind!

The direction of the petals

Trumpet shape

✿ The stem comes out of the center of the flower.

Facing away

Curling inward

Curling outward

Bowl shape

Facing forward

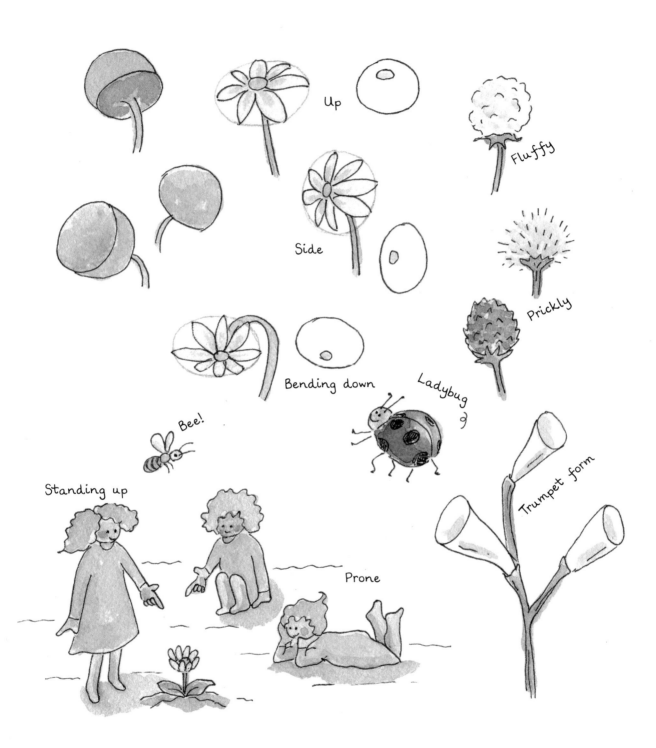

Up

Fluffy

Side

Prickly

Bending down

Ladybug

Bee!

Standing up

Prone

Trumpet form

Gallery of Cylinder-based Shapes

● **Musical Instruments**

Draw tambourines and castanets as squat cylinders.

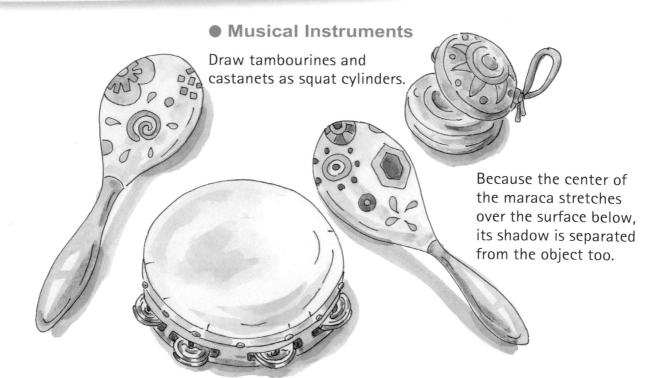

Because the center of the maraca stretches over the surface below, its shadow is separated from the object too.

● **Donuts**

Donuts depicted with pencil and watercolor and without pen lines. The pencil lines blend with the watercolor for a soft finish.

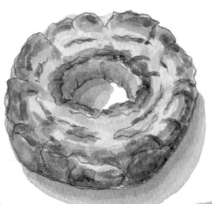

This donut's shape resembles that of a car tire. Draw the edges of the hole with a bold stroke. Depict its crunchy texture with wavy lines.

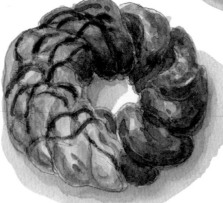

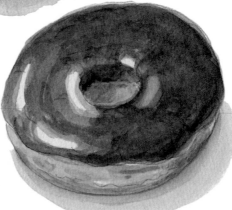

Draw a basic donut shape, and then add the twists.

Depict the gloss of the chocolate icing by leaving the highlights white.

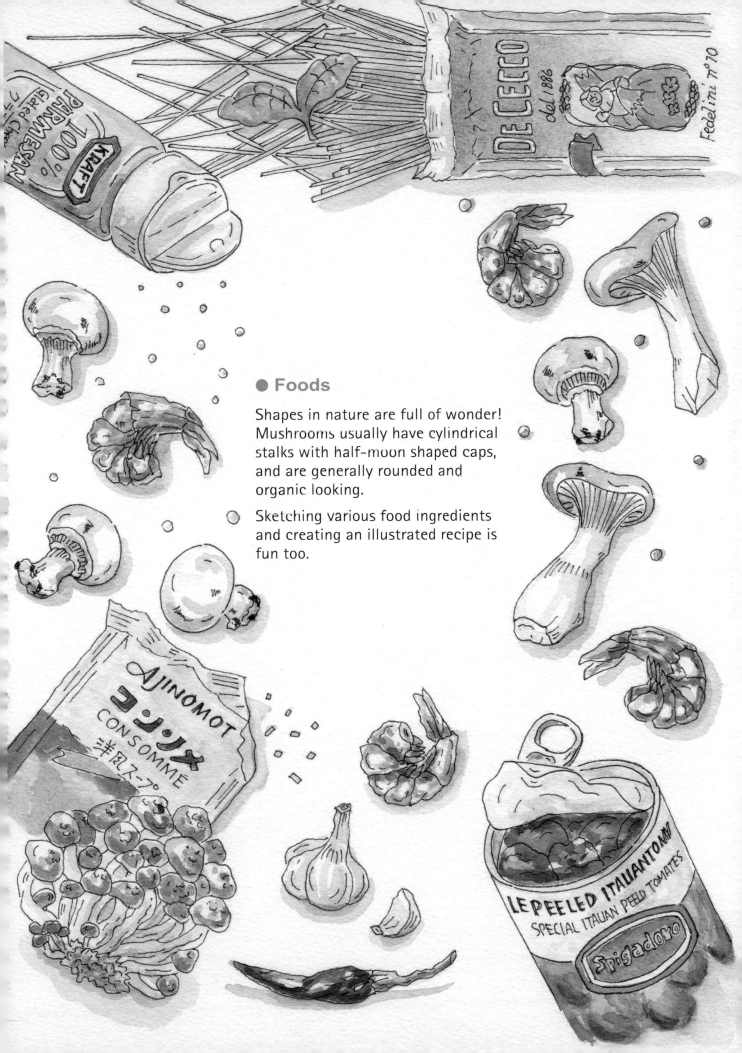

● **Foods**

Shapes in nature are full of wonder!
Mushrooms usually have cylindrical
stalks with half-moon shaped caps,
and are generally rounded and
organic looking.

Sketching various food ingredients
and creating an illustrated recipe is
fun too.

Let's Try Drawing a Teacup with a Handle

How to Draw the Rim

※ This is just one example. How you choose to depict it is up to you! Find your own method of expression.

Porcelain

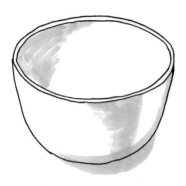

Pottery

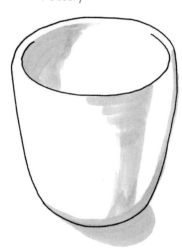

A vessel with thickness like one that is made of pottery doesn't have a lip with squared-off edges, so if you just draw the outline of the rim on the near side, it will have a simple, rustic look.

The rim of a vessel like one that is made of porcelain with a thin rim and a delicate form is drawn with two thin lines to express a sense of tension.

How to Draw the Handle

The visible part of the handle changes from the front to the back along the way

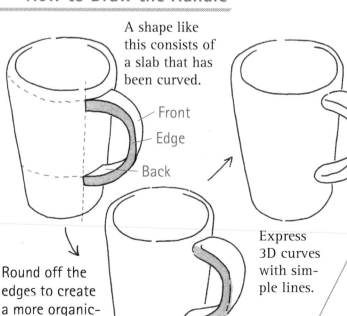

A shape like this consists of a slab that has been curved.

— Front

— Edge

— Back

Round off the edges to create a more organic-looking handle.

Express 3D curves with simple lines.

A handle with no edge thickness looks like a twisted piece of paper.

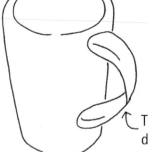

The thickness has disappeared.

Draw the Cup

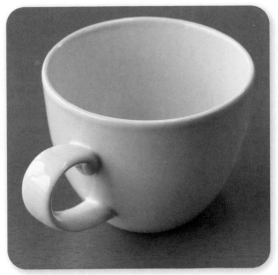

I have selected a white cup so that the shape can be seen clearly.

1 Set down the guide points.

The back of the rim

The left edge of the rim The right edge of the rim

Centerline

The left edge of the bottom | The right edge of the bottom

The front of the bottom

Start by drawing the center line, and then add the guide points. You don't have to be concerned with the handle at this point.

2 Connect the guide points with curves.

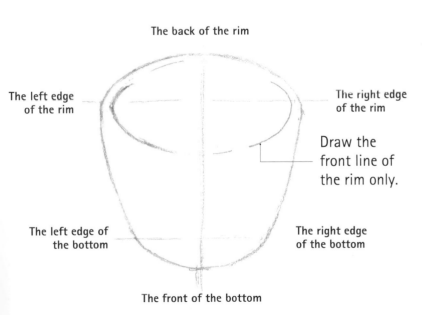

The back of the rim

The left edge of the rim

The right edge of the rim

Draw the front line of the rim only.

The left edge of the bottom

The right edge of the bottom

The front of the bottom

Connect the guide points you made in **Step 1** with curves. The key is not to try to connect them all in one attempt, but to go slowly with short lines. Once you have the outline, draw the rim. (See the right top illustration on the facing page.)

3 Decide on the position of the handle.

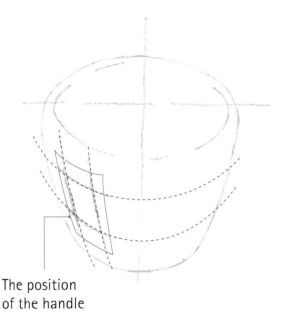

The position of the handle

Focus on the way that the handle is attached to the curved surface.

4 Draw the handle.

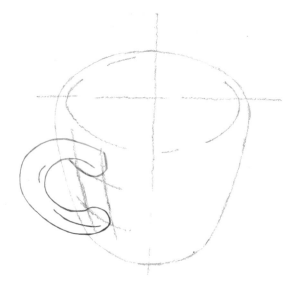

Once you have drawn the shape, erase the supplemental marks and stray lines with a kneaded eraser, and lighten up the undersketch.

 Kneaded eraser

6 Erase the pencil lines.

Kneaded eraser

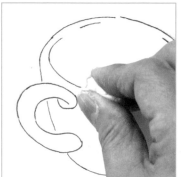

Use the kneaded eraser to erase the pencil lines.

The pen drawing is finished

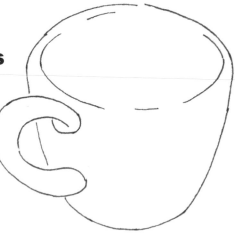

5 Trace with a pen.

Pen

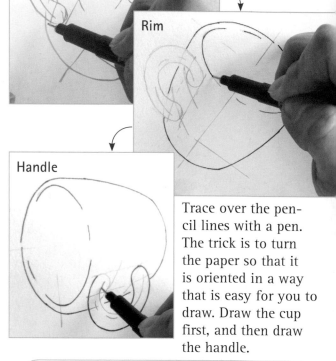

Cup

Rim

Handle

Trace over the pencil lines with a pen. The trick is to turn the paper so that it is oriented in a way that is easy for you to draw. Draw the cup first, and then draw the handle.

What color to paint where?

The light comes from the back and slightly to the left.

The cup's color is white. So, what color should it be painted with? This can actually be any color you like. I want this to have the warm feeling of a pottery cup, so I use sepia in the shadows.

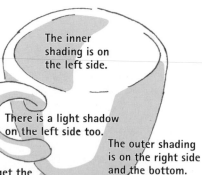

The inner shading is on the left side.

There is a light shadow on the left side too.

The outer shading is on the right side and the bottom.

Don't forget the shading of the handle.

The cast shadow falls toward the right.

7 Paint the shading. **Yellow ochre** **Raw umber**

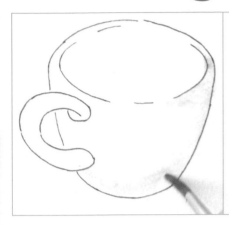 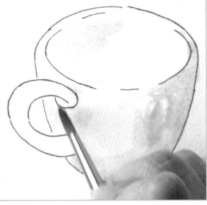

Add color to the shadows. Start by putting in a light layer. Gradually make it darker by layering on more color.

8 Add the cast shadow. **Sepia**

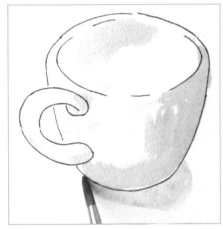

Paint from the bottom of the cup spreading outward. Once it has dried, paint another layer of shadow along the bottom to darken it.

9 Add more color. **Raw umber**

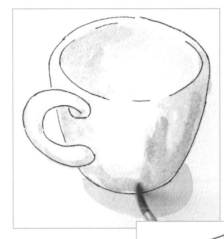

Add color while looking at the overall balance. Darken the front right part and around the bottom of the outer side, and the left part near the rim of the inner side.

Finished

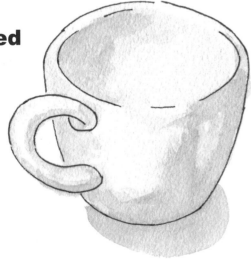

Colors used

Yellow ochre **Raw umber** **Sepia**

61

Let's Try Drawing a Teapot

First, Understand the Shape!

The Positions of the Handle and Spout on a Teapot

No matter which way the teapot is positioned, draw the spout and the handle so that they are on opposite sides of the line that goes through the center of the body.

The spout is positioned at the same height or higher than the height of the body of the pot, to prevent the hot water from spilling.

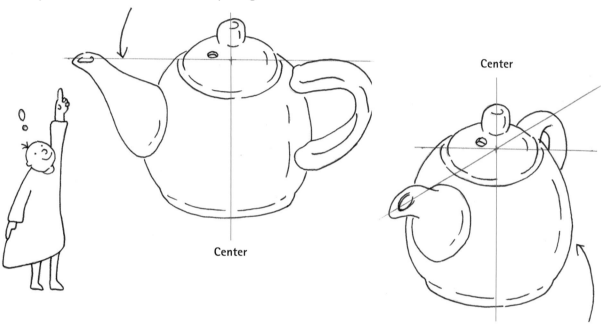

Center

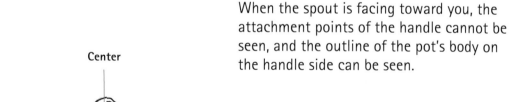

Center

When the spout is facing toward you, the attachment points of the handle cannot be seen, and the outline of the pot's body on the handle side can be seen.

Center

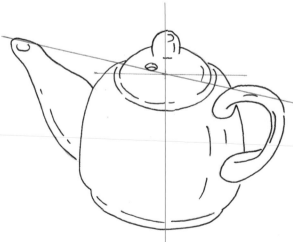

When the handle is facing toward you, its attachment points can be seen, and the outline of the pot's body on the spout side can be seen.

Diagonal line!

Draw the spout and the handle so that they are on a straight line (the diagonal line) that goes through the center line of the body of the pot.

The side center line of the oval on top of the body of the pot becomes the center line of the oval when the lid is removed.

Lateral center line

Draw the attachment points of the handle so that they are parallel to the contour of the body horizontally and vertically. (This is the same for the pot and the cup.)

Center

Draw the Teapot

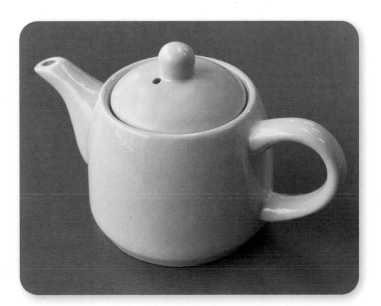

I have selected a white pot to minimize distractions. If you start by drawing it with the lid off, you can draw it in a balanced way.

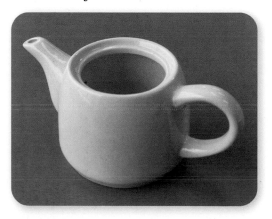

1 Set down the guide points.

Pencil

The back of the rim (without the lid)

The left edge of the rim (without the lid)

The right edge of the rim (without the lid)

The front of the rim (without the lid)

Centerline

The front of the bottom

Draw the vertical centerline and a horizontal line that connects the edges of the rim, and put in guide points at the edges of the front of the rim, the back of the rim and the left and right sides. Determine the position of the front of the bottom too, and make marks along the curves of the body so that they are equidistant on the left and right.

2 Connect the guide points.

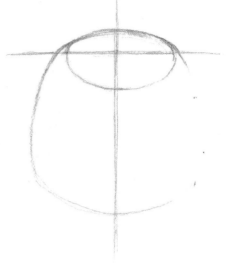

Connect the guide points little by little with short lines.

3 Decide on the positions of the spout and the handle.

The spout is attached to the surface on the other side.

The spout and the handle are on the same axis.

The handle is on the side that can be seen, and the spout is on the side that can't be seen.

4 Draw the spout and the handle.

Draw so the spout and handle rise to intersect the diagonal axis guideline.

5 Draw the lid and the foot

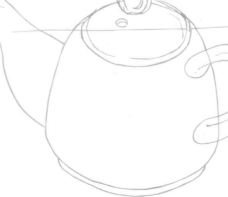

Erase any extraneous lines with a kneaded eraser.

Kneaded eraser

6 Trace with a pen.

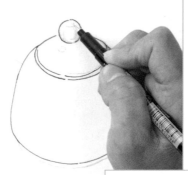

Trace over the pencil lines with a pen. The trick is to turn the paper so that it is oriented in a way that is easy for you to draw. Draw the body of the pot first, and then draw the lid, the spout and the handle.

The pen drawing is finished

Erase any extraneous lines with a kneaded eraser. Kneaded eraser

7 Paint the shadows on the body and the lid.

 Paint Yellow ochre Raw umber

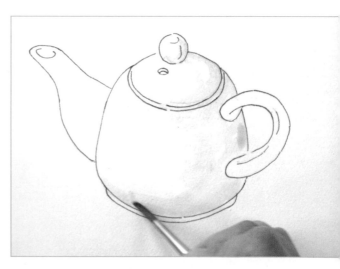

Where are the shadows?

Light comes from the back and a little to the upper left.

Because the teapot has a generally rounded shape, if you add the shadows with curves too there will be a sense of three-dimensionality.

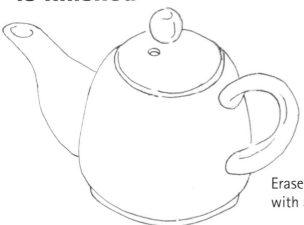

Don't forget the inside of the spout.

The shading of the lid is on the right side.

The spout is shaded underneath.

The shading on the body is on the right and bottom sides.

Don't forget the shading on the handle.

The cast shadow falls a little to the right.

8 Add shadows to the body. **Yellow ochre** **Raw umber**

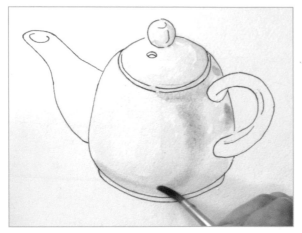

The body of the pot is round, so add the shading with curves too.

9 Add shadows to the lid. **Raw umber**

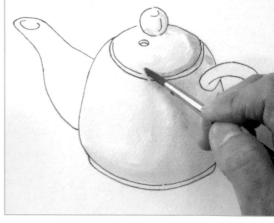

Add the shading to the side of the rim.

10 Add shading to the spout. **Yellow ochre** **Raw umber**

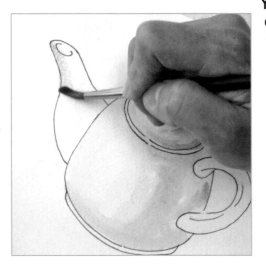

Paint while stroking the brush along the outline. If you are right handed this easier to do if you turn the paper so that the tip of the brush faces to the left (If you are left handed, turn the paper so the tip of the brush faces to the right).

11 Paint the foot. **Raw umber**

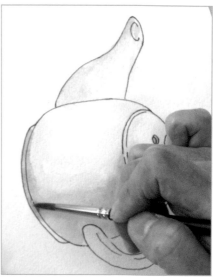

12 Add shading to the handle. **Raw umber**

Leave this part of the edge of the handle white.

13 Add the cast shadows. **Sepia**

Paint from the bottom, spreading to the outside.

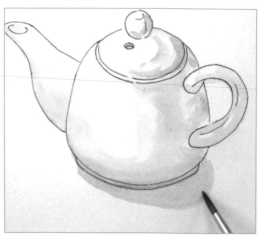

14 Add to the shading on the handle.

 Yellow ochre **Raw umber**

15 Paint the thickness of the lid.

 Yellow ochre **Raw umber** **Sepia**

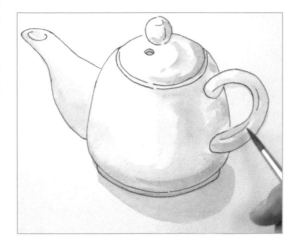

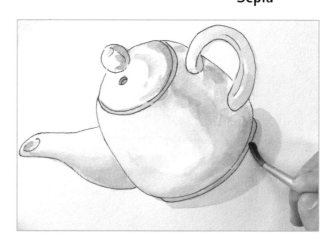

16 Add to the shading on the spout.

 Sepia

17 Add the cast shadow.

 Sepia

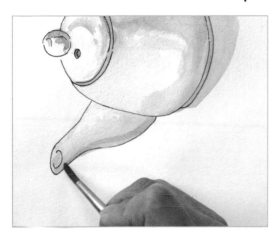

Finished

Colors used

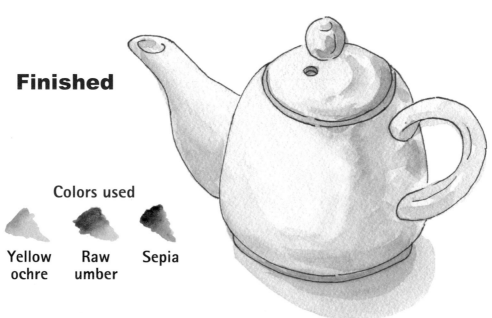

Yellow ochre **Raw umber** **Sepia**

Cup and Pot Gallery

● Garlic Saver

The lettering is raised, so let the thickness of the edges show at the top. The holes sink inward, so let the thickness of the edges show at the bottom.

● Pitcher

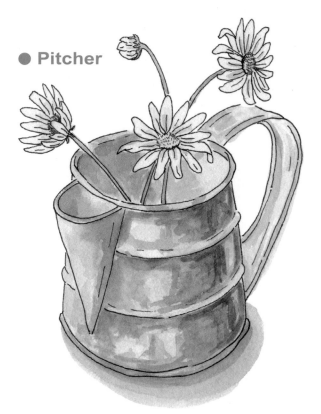

Observe the play of lights and shadows on the ridges of the body as you draw.

● Tea Set

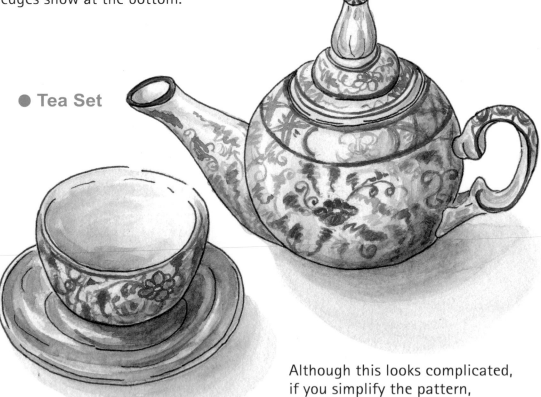

Although this looks complicated, if you simplify the pattern, the basic shapes are the same as with the simple pot and cup.

Variations of the Cylinder Shape

Use a slice of a cylinder to draw a cheese container

1. Draw the oval of the top surface
2. Add thickness
3. Divide into six pieces
4. Add the center lines for each piece
5. Add the text

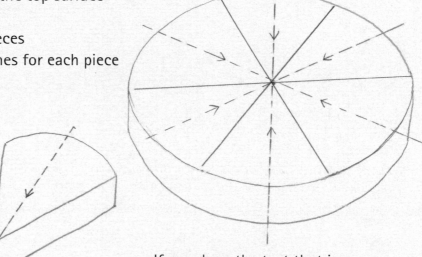

If you draw the text that is along the perimeter of the circle so that the letters are oriented toward the center, a sense of three-dimensionality is created.

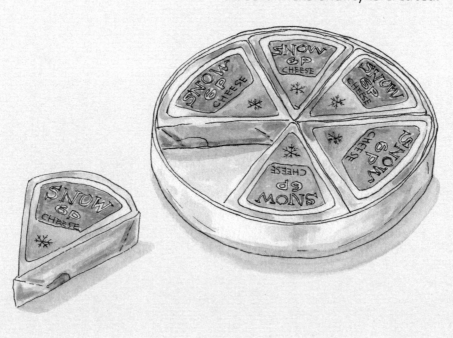

Six-piece cheese carton

Drawing Flat Objects

Although they look simple, for some reason you can't nail down their shapes ... that's because you haven't gotten an accurate grasp of the shapes. Understand the shape of each object as you draw them!

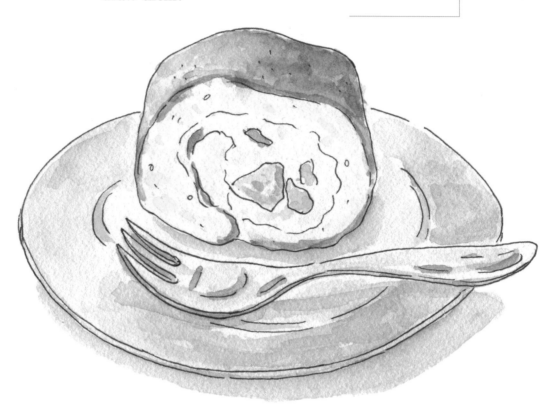

If you study a plate of delicious-looking cake, you can see that it is made up of several parts: a flat plate, a flat fork (with curves) and a squat cylinder that is standing on end, which represents the cake. Let's try drawing this while getting our heads around each of the shapes.

Colors used

Carmine	Deep yellow	Viridian	Hooker's green	Ultramarine	Turquoise blue

How to draw the plate ▶ page 71
How to draw the fork ▶ page 74
How to draw the composition ▶ page 76

Yellow ochre	Raw umber	Burnt umber	Sepia	Black

A Basic Plate

The farther away you place the plate, the closer it appears to eye level (the horizon line), so the farther away it appears, the more it will seem that you are looking at the plate from the side. For that reason, the farther away it is, the better you will be able to see the thickness of the plate and the "foot" below it.

Narrower

Wider

Horizontal center line

If you make the nearer half from the line connecting the vertices of the oval (the horizontal center line of the plate) a little wider, a sense of three-dimensionality is created.

Let's Draw a Basic Plate

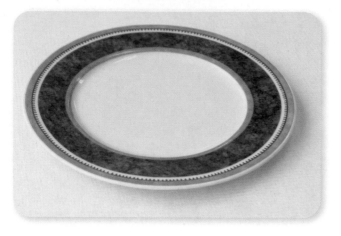

Key Point!

Narrower

Wider

Make the near side of
the plate a little wider

1 Set down the guide points. Pencil

Draw the vertical and horizontal center lines,
and make marks for the near, far, left and
right edges.

2 Connect the guide points.

Draw short lines a little at a time in curves to
connect the guide points.

3 Draw the details.

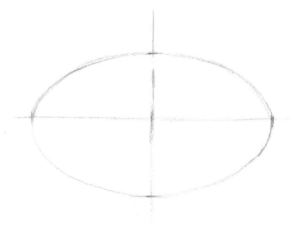

Add the inner oval and the thickness of the lip
of the plate.

Erase any extraneous lines, and lighten up
the sketch lines with a kneaded eraser. Kneaded eraser

4 Trace the outline with a pen. Pen

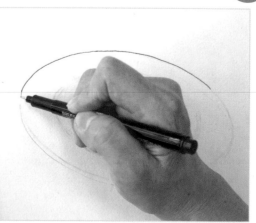

Turn the paper as you draw to make it
easier to trace the outline with your pen.

5 Trace the inside oval and the thickness of the lip of the plate.

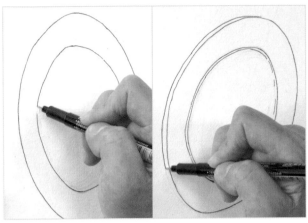

As long as the first 4 guide points you made are accurate, it's fine if the lines are a bit wobbly. Don't get too concerned about perfection and just draw the lines in a relaxed way.

The Pen Drawing is Finished

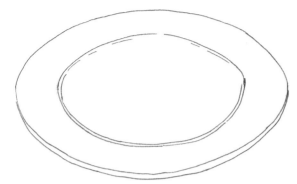

Press the kneaded eraser on the paper to erase the pencil lines.

Kneaded eraser

6 Paint the outside oval.

Paint

Ultramarine

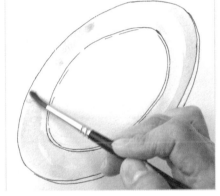

Simplify the pattern, and add tonal variations. The actual plate is mostly flat, so there are no specificly shaded areas. In a case like this, define light and dark areas to suit your taste. In this instance, we have made the right bottom side darker to add a shadow.

7 Paint the inner oval.

Sepia Black

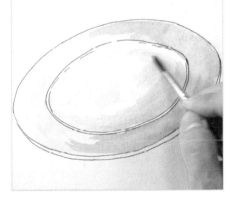

Dilute the paint, and add light and dark areas so that the right bottom part looks like it is shaded. Don't worry if the strokes of the brush are visible. Trying to over paint to create a clean gradation is the way to failure!

8 Add the decorative band.

Viridian

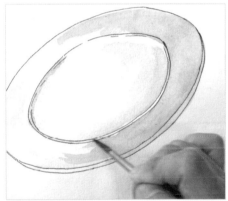

Use the point of the brush to paint in the band while turning the paper.

Finished

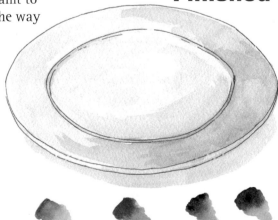

9 Add the cast shadow.

Sepia

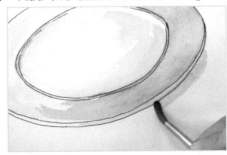

Put the point of the brush against the edge of the plate as you start to paint, and spread the diluted paint to the outside.

Colors used Viridian Ultramarine Sepia Black

73

Let's Try Drawing a Spoon and a Fork

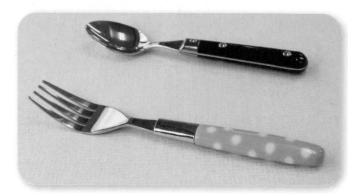

1 Decide on the angle at which the fork will be placed, and draw the centerline.

Front edge (the points)

The root of the tines

The swell of the fork

The neck

The arch

Center line

End

2 Add parallel lines at key points of the fork—the front edge, the root of the tines, the swell of the fork, the neck of the handle, the arch of the handle and the end of the fork.

3 Create guide points on the fork following the shape. If you make the distance between the center line and the guide points narrower on the far side than on the near side, you will create a sense of three-dimensionality.

A little bit above

Front edge

Narrow

Wide

Make the parallel line for the edge of the form a little higher (if you draw it on the center line, the fork will look like a pitchfork).

Center line

4 Draw the outline of the fork following the guide points made on the parallel lines.

▶ Draw the spoon in the same way. Make the front edge of the spoon a little higher too (if you draw the edge on the center line, it will look like a flat paddle).

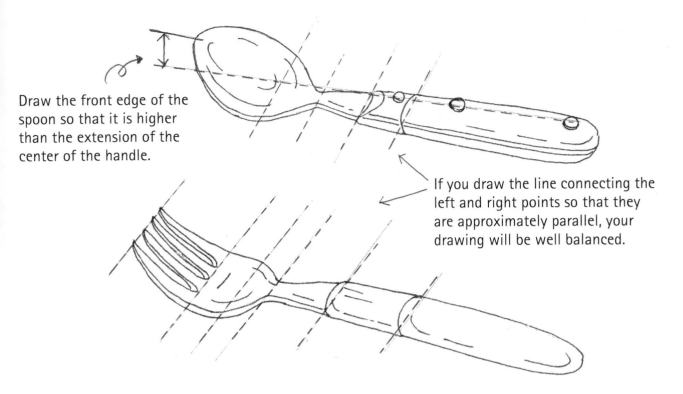

Draw the front edge of the spoon so that it is higher than the extension of the center of the handle.

If you draw the line connecting the left and right points so that they are approximately parallel, your drawing will be well balanced.

About Shadows

The Shape of the Shadow Where the Utensil Touches the Table and Where it's Not Touching

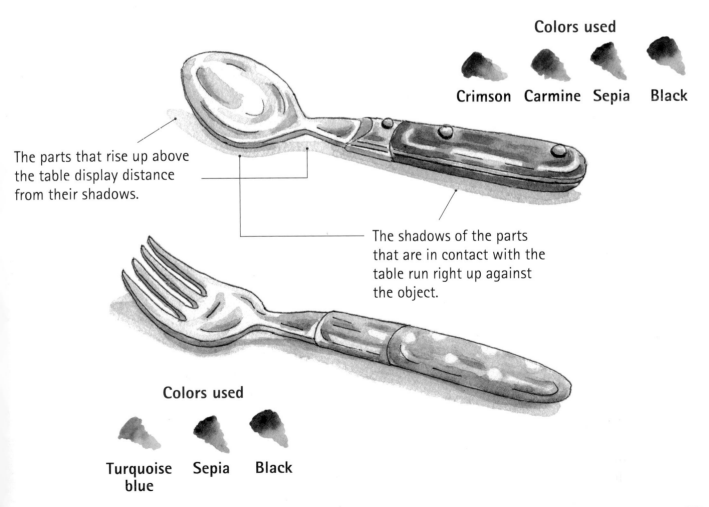

Colors used

Crimson Carmine Sepia Black

The parts that rise up above the table display distance from their shadows.

The shadows of the parts that are in contact with the table run right up against the object.

Colors used

Turquoise blue Sepia Black

Let's Try Drawing a Roll Cake on a Plate

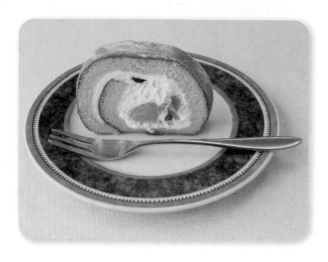

1 Set down the guide points.

Draw the vertical and horizontal center lines, and put guide points for the front, back, left and right sides of the plate. Decide on the approximate position of the roll cake at the same time too.

2 Connect the guide points.

Draw the curved lines a little at a time using short lines to connect the guide lines.

3 Draw the roll cake.

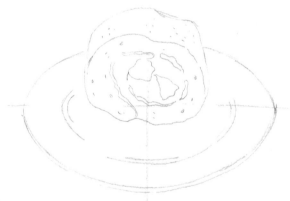

Add dots to express the sugar on top and indicate the texture of the sponge cake.

4 Draw the key lines for the fork.

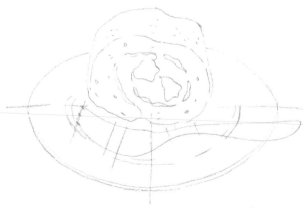

Draw parallel lines for the key points on the fork such as the points, the roots of the tines, the swelling part of the fork, the end of the handle and so on.

5 Draw the details of the fork using the guidelines.

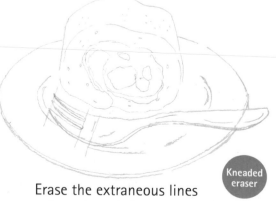

Erase the extraneous lines using a kneaded eraser.

6 Trace with a pen.

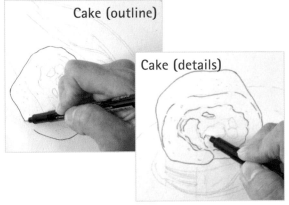

Cake (outline)

Cake (details)

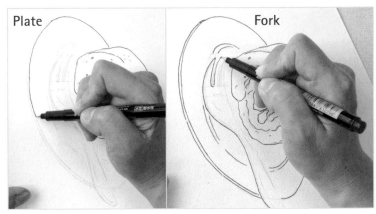

Plate

Fork

Draw in the following order: the roll cake outline → the details of the cake → the plate → the fork. The key is to turn the paper as you go to facilitate drawing.

The Pen Drawing is Finished

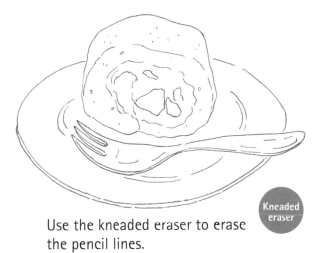

Use the kneaded eraser to erase the pencil lines.

Kneaded eraser

8 Paint the fruit.

Carmine Deep yellow Hooker's green

Paint in the orange (orange), strawberry (red) and kiwi (green).

7 Paint the sponge part of the cake.

Paint Yellow ochre Raw umber

Paint the top surface and the front-facing surface. The right side of the top surface is shaded, so darken it.

9 Paint the shaded parts of the fork.

Black

Paint the dark parts and the contours of the fork.

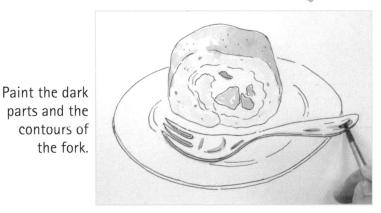

77

10 Paint the plate.

Start by putting down a layer of diluted paint on the outer rim.

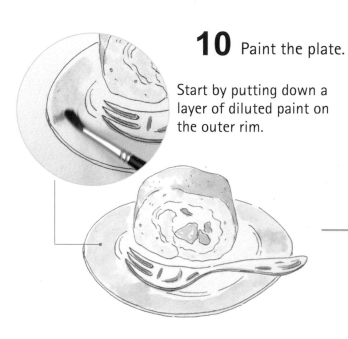

Ultramarine

Next, make the paint thicker and paint the shaded parts (the right and front sides).

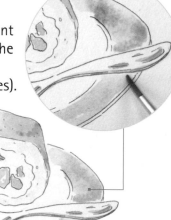

11 Bring out the texture of the sponge cake.

Add orange to the front surface to show its bumpiness. Shade the orange too.

Yellow ochre

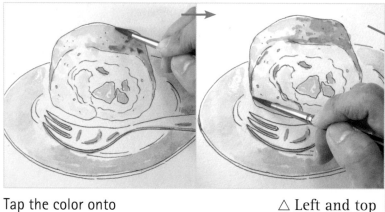

Tap the color onto the right front side.

Yellow ochre **Burnt sienna**

△ Left and top

Add color to the rolled parts of the cake.

Burnt sienna

▷ Right and bottom

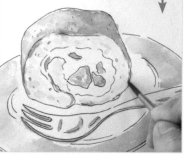

12 Paint the whipped cream.

Turquoise blue

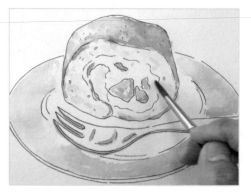

13 Paint the fork.

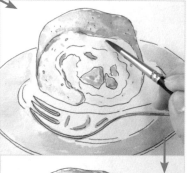

Black

Paint with a diluted gray tone while leaving the shiny parts white. It's okay if the paint goes over the shaded parts you've already painted.

14 Paint the inner oval of the plate. Black

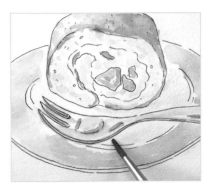

Thin out the paint and apply it roughly.

15 Add color to the plate. Ultramarine

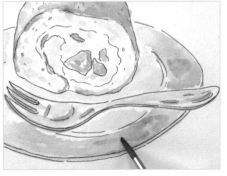

Add more color while looking at the overall balance.

16 Paint the decorative line. Viridian

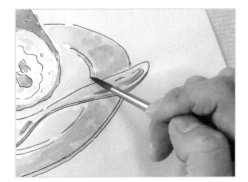

17 Put in the shadows.

Sepia

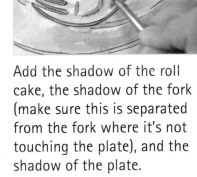

Add the shadow of the roll cake, the shadow of the fork (make sure this is separated from the fork where it's not touching the plate), and the shadow of the plate.

18 Finish. 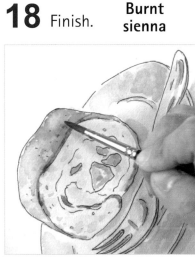 Burnt sienna

Add more color while looking at the overall color to finish. Here, I am adding more brown to the roll cake, but you should add more color wherever you think it is needed.

Finished

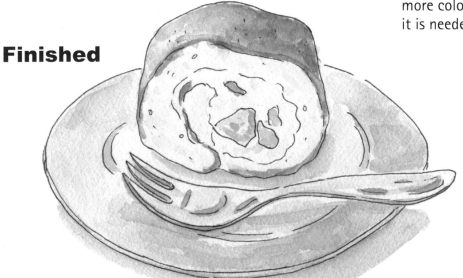

Let's Try Drawing a Sandwich on a Plate

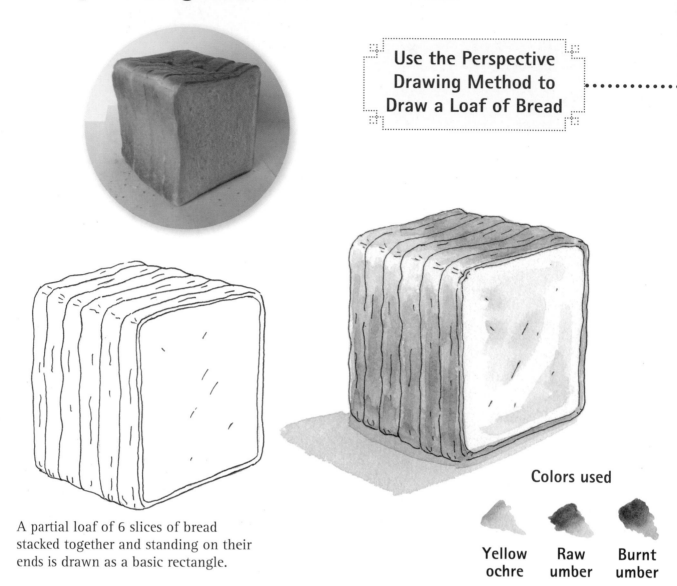

Use the Perspective
Drawing Method to
Draw a Loaf of Bread

A partial loaf of 6 slices of bread stacked together and standing on their ends is drawn as a basic rectangle.

Colors used

Yellow ochre Raw umber Burnt umber

A Review of the Perspective Drawing Method

The plate: Use the single point perspective method.
The loaf of bread: Use the two-point perspective method.

(Refer to page 8 for perspective-drawing basics.)

Vanishing point of the loaf of bread

The plate and the sandwiches are seen at the same eye level, so the extensions of their perspective lines come together on the same horizontal line.

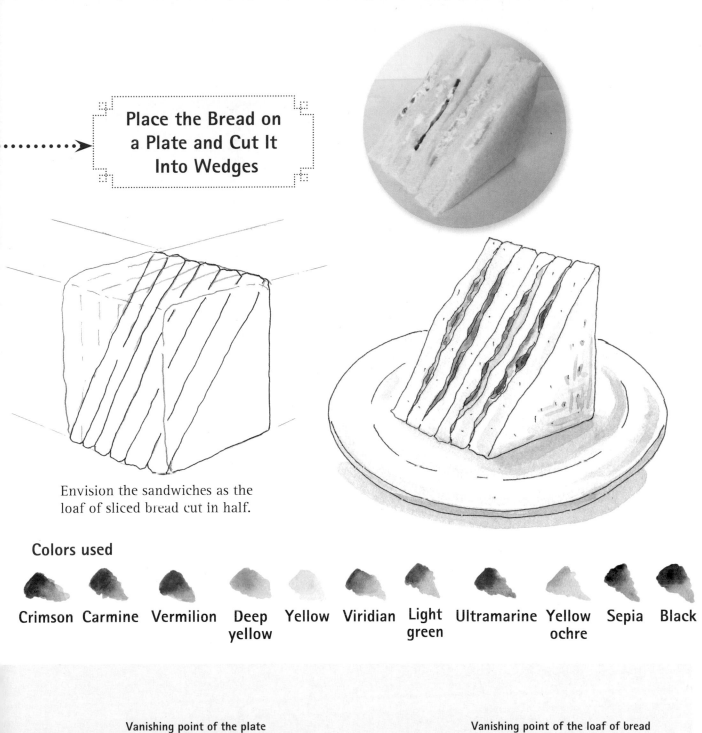

Place the Bread on a Plate and Cut It Into Wedges

Envision the sandwiches as the loaf of sliced bread cut in half.

Colors used

Crimson Carmine Vermilion Deep yellow Yellow Viridian Light green Ultramarine Yellow ochre Sepia Black

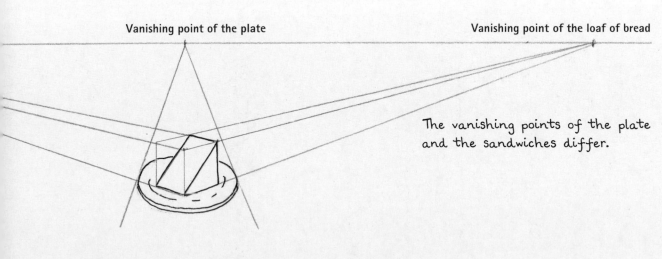

Vanishing point of the plate

Vanishing point of the loaf of bread

The vanishing points of the plate and the sandwiches differ.

A Gallery of Plates with Objects On Them

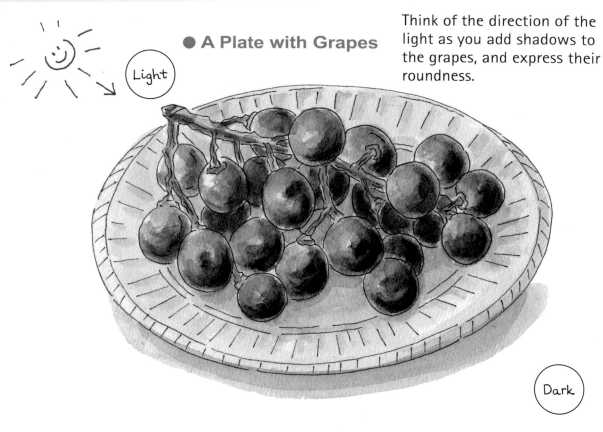

Light

Dark

● A Plate with Grapes

Think of the direction of the light as you add shadows to the grapes, and express their roundness.

● A Plate with a Cup and Ivy

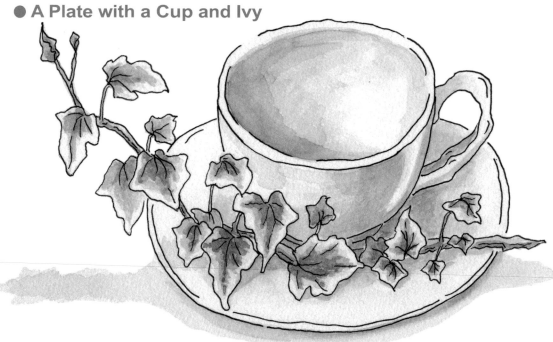

Draw the places that are hidden by the ivy as if you could see through it when you draw the undersketch.

● A Plate with a Box-shaped Slice of Cake

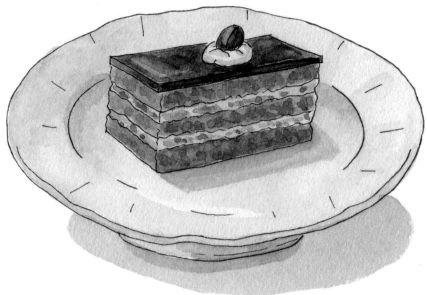

The shadow of a plate with a high foot is a separated somewhat from the plate.

↑↓ In order to make it seem as if the cake is firmly situated on the plate, align the top surface of the plate with the bottom surface of the cake.

● A Square Plate with a Cylindrical Cake

The inner square of the plate is horizontal, and the outer square lip of the plate is raised a little diagonally, but because the plate is drawn with single-point perspective, both squares meet at the same vanishing point.

Depicting Flat Objects

■ Scissors

① Extend the lines that connect the left and right finger rings, and fix the vanishing point as the point where they meet.

② Draw the line, starting in-between the finger rings (the center) to where the pivot screw is (the center line of the scissors).

③ Determine the length of the scissors on the center-line (A), and draw a line from there to the vanishing point. Determine the positions of the ends of the scissor blades on that line (B and C). Make the distance from A to C (on the near side) slightly longer than the distance from A to B (on the far side). In addition, if you make the width of the near side finger ring a little bit wider, a sense of three-dimensionality will be created.

▶ The length of the scissors from the screw to the blade ends and the screw to the finger rings is not always the same. In addition, with some designs it's not possible to draw a straight line from the finger ring to the blade end, so observe carefully as you draw.

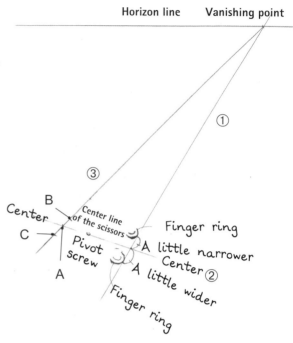

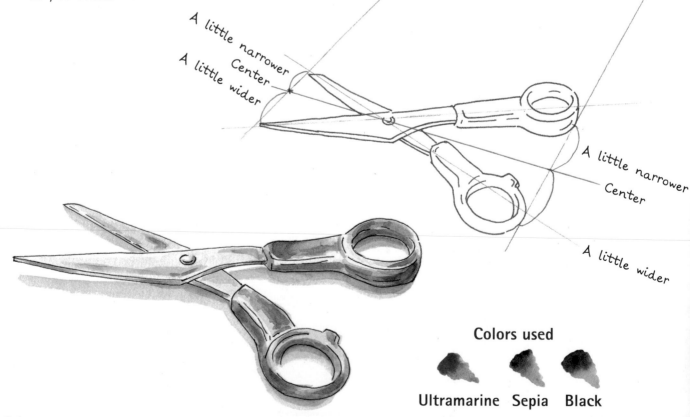

Colors used

Ultramarine Sepia Black

■ A Wine Bottle Opener

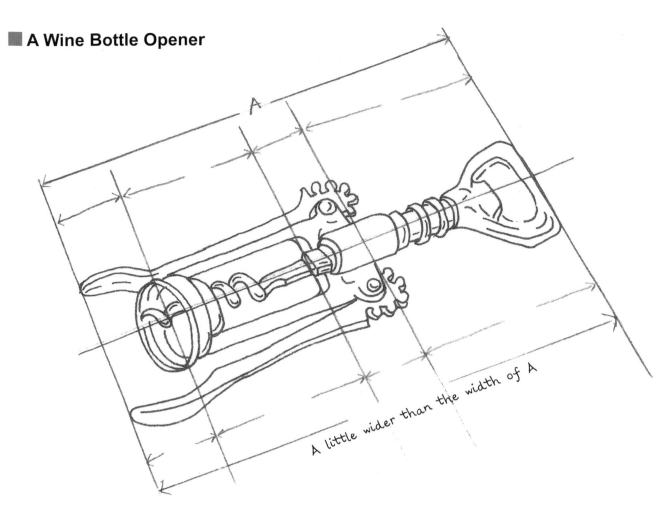

A
A little wider than the width of A

▶ Use a flat rectangle shape as the base, and measure the ratios accurately.

▶ Be aware of the cylinder shape for the central part of the end that receives the mouth of the bottle to be opened (where the corkscrew emerges).

Colors used

Ultramarine Sepia Black

■ Santa Clause Ornaments

★ How to Draw a Star Shape ★

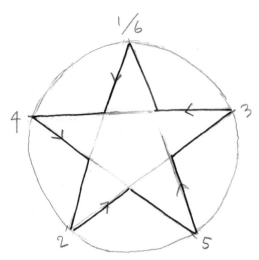

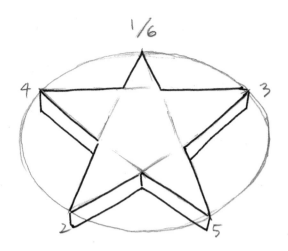

When looking at the star from directly above, draw a circle and make marks dividing the circle into 5 equal parts. Connect the marks in numerical order, from 1 to 6.

Depict the star from the diagonal-front perspective when you want to show a sense of depth. Draw an oval rather than a circle and mark it up as described to the left. Indicate depth on the edge of the star on the near side.

Make it look three-dimensional!

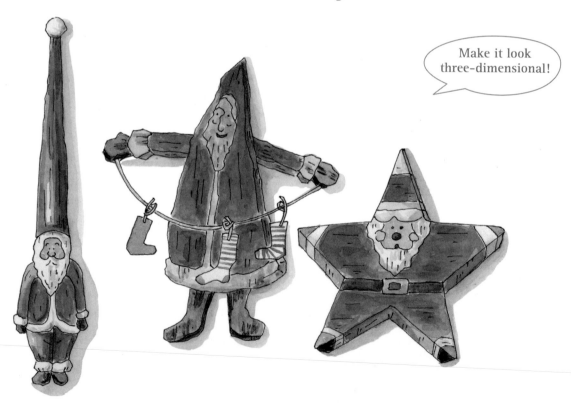

Colors used

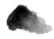

| Crimson | Carmine | Jaune brillant | Viridian | Yellow ochre | Raw umber | Sepia | Black |

■ A Hat and a Trowel

A compound shape

A low cylinder

A two-dimensional oval

Draw the curved part of the heel of the blade so that the left and right sides are connected.

Because the hat is made of fabric, draw a supple-looking outline to express the hat's wrinkles and wear. If you add the stitches along the seams, it will appear fabric-like.

If you draw the tip of the blade a little bit above the center, it will look like you could scoop up dirt with the concave blade.

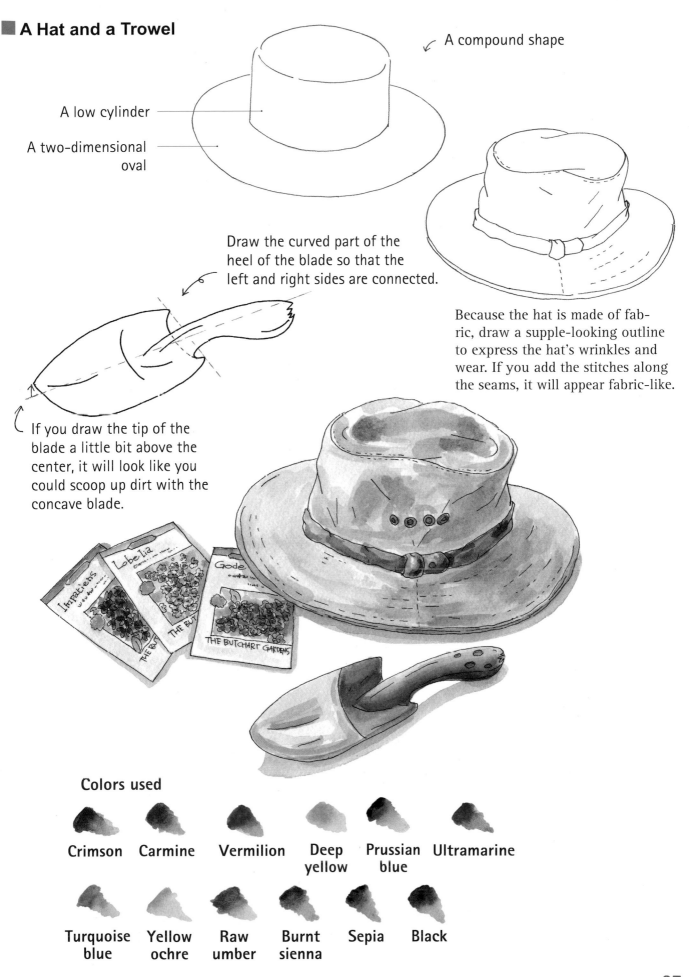

Colors used

Crimson	Carmine	Vermilion	Deep yellow	Prussian blue	Ultramarine

Turquoise blue	Yellow ochre	Raw umber	Burnt sienna	Sepia	Black

Additional Information

Art Supplies

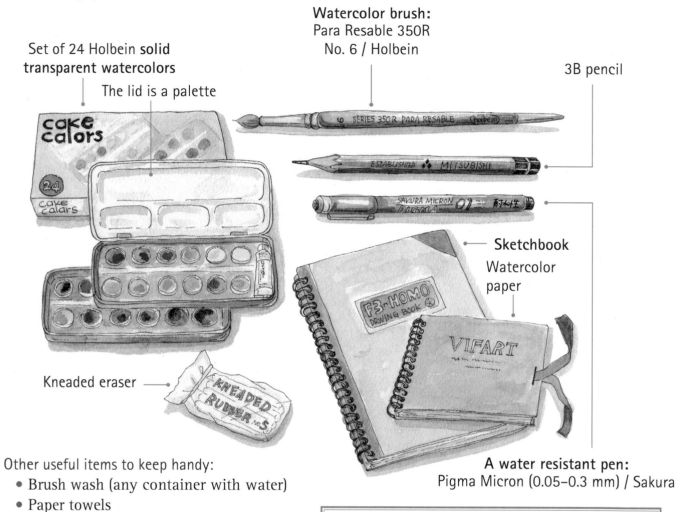

Set of 24 Holbein **solid transparent watercolors**

The lid is a palette

Watercolor brush:
Para Resable 350R
No. 6 / Holbein

3B pencil

Kneaded eraser

Sketchbook
Watercolor paper

A water resistant pen:
Pigma Micron (0.05–0.3 mm) / Sakura

Other useful items to keep handy:
- Brush wash (any container with water)
- Paper towels

▶ There are many other art supply manufacturers from all around the world. It's fun to find the art materials that you prefer.

▶ If you are using watercolors in tubes, squeeze out a little of each color in the small wells of a palette, let them dry, and then use them in the same way that you would use solid watercolors. Continue to dry and reuse the paint in the palette wells across multiple sessions.

Transparent and opaque watercolors

There are transparent and opaque watercolor paints. In this book we use the transparent type. When you paint a second transparent color over a layer of transparent paint that has dried, the original color will be partially visible through the second color. Transparent watercolors are known for their beautiful blending and subtle layering characteristics—they are a recommended medium.

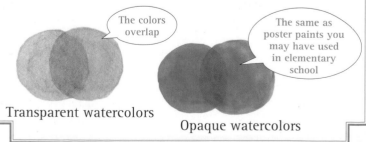

The colors overlap

The same as poster paints you may have used in elementary school

Transparent watercolors

Opaque watercolors

Review: Basic Steps

1 Guide lines

Draw the guide lines with a pencil.

2 Undersketch with a pencil

Draw the approximate shape with a pencil.

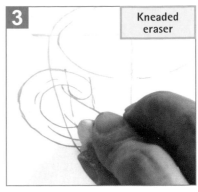

3 Kneaded eraser

Erase extraneous lines with a kneaded eraser.

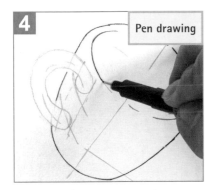

4 Pen drawing

Trace with a water-resistant pen.

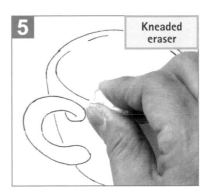

5 Kneaded eraser

Erase the remaining pencil lines with a kneaded eraser.

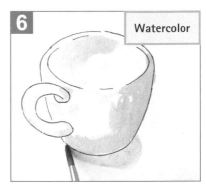

6 Watercolor

Paint on colors with transparent watercolors.

About Kneaded Erasers

The kneaded eraser is an important tool. It is used in a different way than the usual white plastic or pink rubber erasers that you use when writing, so I will introduce you to it here.

Characteristics

▶ It is soft, and the shape can be changed at will
▶ There are no eraser crumbs
▶ It does not damage the paper

How to prepare a kneaded eraser

▶ Before you use a kneaded eraser, rip it up into easy-to-use pieces, and knead them well. To knead, stretch the piece into a long strand, and then fold it up. Repeat several times.

Stretch it waaay out!

Knead knead

When you use a kneaded eraser, press it onto the paper and pull to lift pencil marks

▶ Pinch the kneaded eraser with your fingers, press it on the paper, and pull the eraser through the pencil marks. When the surface of the kneaded eraser becomes grimy with pencil dust, knead that dust into the eraser. Do not rub the kneaded eraser on the paper as you would with a regular eraser. Over time, the kneaded eraser will become a uniformly dark lump. When it becomes nearly black, switch to a new one.

How to Use Solid Watercolors

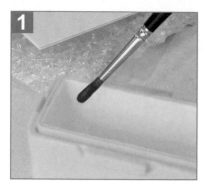

1

Wet the brush, and squeeze off the excess water on the edge of the water container.

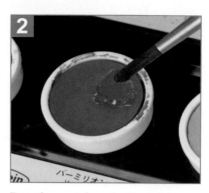

2

Put the wet brush directly on the paint cake to pick up some color.

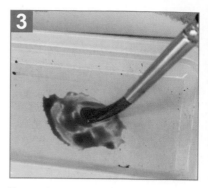

3

Deposit some paint on the palette.

4

Check the color on a piece of scrap paper.

5

Apply paint to the picture.

Don't paint with concentrated color right away! If you think the color you're applying is too thin, paint on several layers to increase the saturation.

Mixing colors

2-A

Pick up some of Color A.

2-B

With the brush still loaded with Color A paint, pick up some of Color B.

1 3 4 5

Steps 1, 3, 4 and 5 are the same as laid out above. Color A gets on Color B's paint cake, but don't be concerned. I will explain how to take care of your paints on the facing page.

How to Take Care of Your Paints

Because we took some yellow paint with a brush that already had red paint on it, the solid yellow paint cake has some red paint on it.

Wash the brush well, and then paint the surface of the solid watercolor cake with clean water.

Absorb the moisture with tissue paper.

It is now a clean yellow cake of paint once again.

How to Take Care of Your Palette

The palette has lots of dried pigment on it.

Paint the palette with clean water.

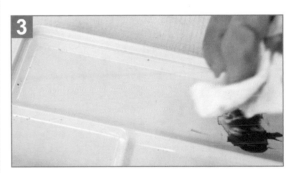

Wipe it off with tissue paper or a paper towel, and it is clean again.

The Handy Watercolor Brush Pen

Aquash / Pentel

This type of brush contains a reservoir in the handle. When you squeeze it lightly, the brush is moistened. When you squeeze it firmly, water drops emerge. Grasp it lightly when painting, and squeeze it firmly when you are dripping water onto your paint or palette. Wipe your items off with tissue paper or a paper towel, and keep painting!

Color Swatches

Solid Transparent Watercolors
24-color Set / Holbein

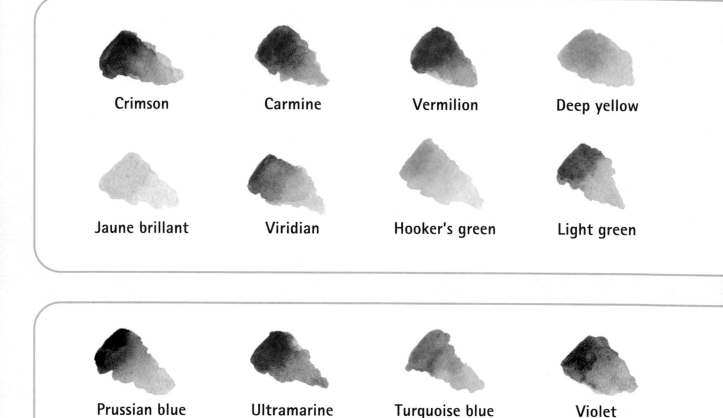

Crimson Carmine Vermilion Deep yellow

Jaune brillant Viridian Hooker's green Light green

Prussian blue Ultramarine Turquoise blue Violet

Yellow ochre Raw umber Burnt umber Burnt sienna

It is very convenient to have a set of gradated color swatches where you can see at a glance what the colors look like when the pigments are concentrated, and what they look like when they are diluted.

If you are using a different brand of transparent watercolors than the colors that are described on these pages, make your own color swatches. Even if they have the same names, colors can vary subtly between manufacturers.

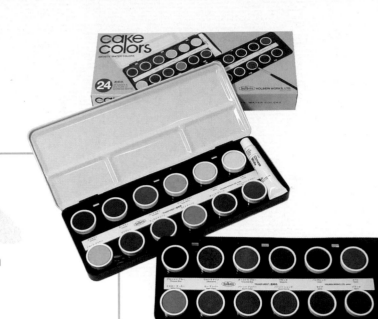

Yellow

Lemon

Olive green **Greenish yellow**

Magenta **Opera**

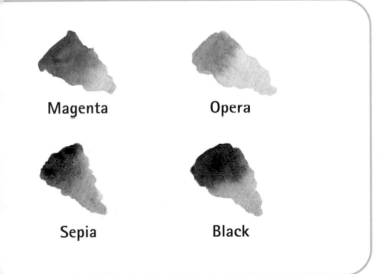

Sepia **Black**

How to Make Color Swatches
(Use Watercolor Paper)

1 Paint a thick patch of saturated paint.

2 Wash the brush, and then load it with water.

3 Touch the edge of the paint patch you painted with the tip of the brush and dissolve it.

4 Move the brush in a zigzag pattern and spread out the paint.

White Paint
Although the set includes a tube of white paint, because watercolors become opaque when white is mixed with them, white is not suitable for mixing.

Layered Paint Swatches

Solid Transparent Watercolors
24-color Set / Holbein

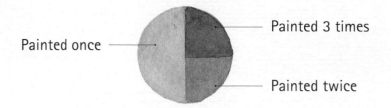

Painted once —

— Painted 3 times

— Painted twice

Because you can see through transparent colors to the colors underneath, the more layers you paint, the more saturated the color becomes. These color swatches are all made with the same paints painted in layers.

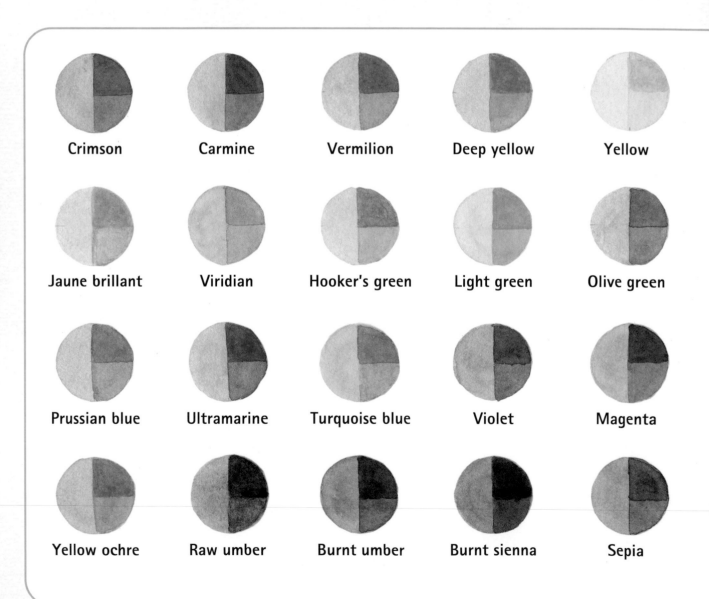

| Crimson | Carmine | Vermilion | Deep yellow | Yellow |

| Jaune brillant | Viridian | Hooker's green | Light green | Olive green |

| Prussian blue | Ultramarine | Turquoise blue | Violet | Magenta |

| Yellow ochre | Raw umber | Burnt umber | Burnt sienna | Sepia |

Mixed Color Swatches

Solid Transparent Watercolors
24-color Set / Holbein

Colors mixed on the palette before being painted on, and colors that are painted singly on the paper, allowed to dry and then layered with another color look subtly different, even if the same paint colors are being used.

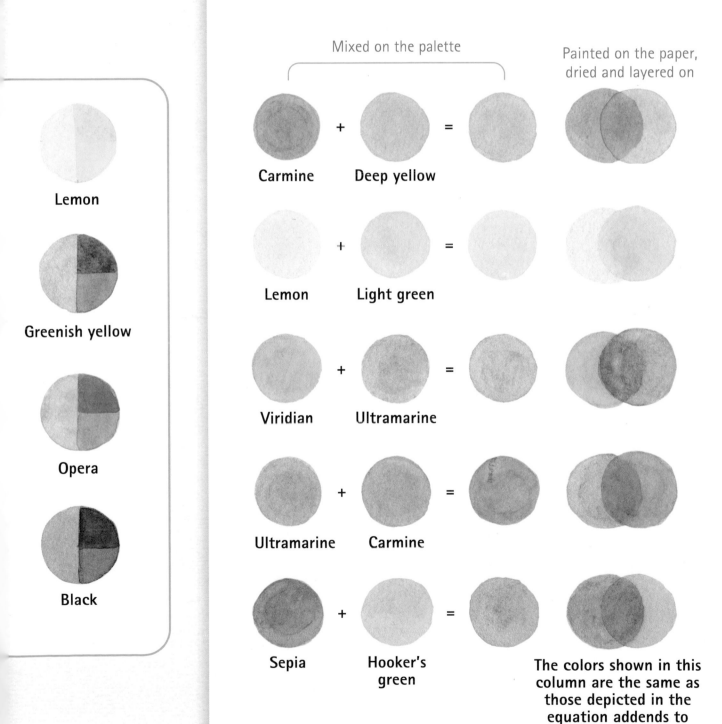

Lemon

Greenish yellow

Opera

Black

Mixed on the palette

Painted on the paper, dried and layered on

Carmine + Deep yellow =

Lemon + Light green =

Viridian + Ultramarine =

Ultramarine + Carmine =

Sepia + Hooker's green =

The colors shown in this column are the same as those depicted in the equation addends to the left.

"Books to Span the East and West"

Tuttle Publishing was founded in 1832 in the small New England town of Rutland, Vermont [USA]. Our core values remain as strong today as they were then—to publish best-in-class books which bring people together one page at a time. In 1948, we established a publishing outpost in Japan—and Tuttle is now a leader in publishing English-language books about the arts, languages and cultures of Asia. The world has become a much smaller place today and Asia's economic and cultural influence has grown. Yet the need for meaningful dialogue and information about this diverse region has never been greater. Over the past seven decades, Tuttle has published thousands of books on subjects ranging from martial arts and paper crafts to language learning and literature—and our talented authors, illustrators, designers and photographers have won many prestigious awards. We welcome you to explore the wealth of information available on Asia at www.tuttlepublishing.com.

Published by Tuttle Publishing, an imprint of Periplus Editions (HK) Ltd.

www.tuttlepublishing.com

ISBN 978-0-8048-5622-5

SHIPPAI SHINAI RAKURAKU SKETCH
Copyright © Tomoko Kuramae 2015
English translation rights arranged with
MAAR-sha Publishing Co., Ltd.
through Japan UNI Agency, Inc., Tokyo

Distributed by:

North America, Latin America & Europe
Tuttle Publishing
364 Innovation Drive
North Clarendon
VT 05759-9436 U.S.A.
Tel: (802) 773-8930
Fax: (802) 773-6993
info@tuttlepublishing.com
www.tuttlepublishing.com

Asia Pacific
Berkeley Books Pte. Ltd.
3 Kallang Sector, #04-01
Singapore 349278
Tel: (65) 6741-2178
Fax: (65) 6741-2179
inquiries@periplus.com.sg
www.tuttlepublishing.com

Printed in China 2212EP
25 24 23 22 10 9 8 7 6 5 4 3 2 1